CAMBRIDGE INTRODUCTION TO

Nineteenth-Century Archit

D0118232

Nineteenth-Century Architecture

DONALD MARTIN REYNOLDS

CAMBRIDGE
UNIVERSITY PRESS

In memory of Peter C. Zlobik and Genevieve Logue Zlobik,
and to their daughter, Nancy Zlobik Reynolds, my wife

Published by the Press Syndicate of the University of Cambridge
The Pitt Building, Trumpington Street, Cambridge CB2 1RP
40 West 20th Street, New York, NY 10011–4211, USA
10 Stamford Road, Oakleigh, Victoria 3166, Australia

© Cambridge University Press 1992

First published 1992

Book designed by Peter Ducker MSTD

Printed in Great Britain by Butler & Tanner, Frome

British Library cataloguing in publication data

A catalogue record for this book is available from the British Library

Library of Congress cataloguing in publication data
Reynolds, Donald M.
Nineteenth-century architecture/
Donald Martin Reynolds.
 p. cm. – Cambridge Introduction to Art
Includes bibliographical references (p.) and index.
ISBN 0–521–35683–0 (paper)
1. Architecture, Modern–19th century.
I. Title. NA645.R49 1992
724'.5–dc20 91–13441 CIP

ISBN 0 521 35683 0 paperback

Contents

Contents

Introduction

Much of nineteenth-century architecture has its roots in the classicism of ancient Greece and Rome. In the course of the century, the durability and adaptability of those traditions was demonstrated, as classical forms appeared at one and the same time in industrial, governmental, religious and domestic architecture.

The Neoclassicism of the nineteenth century had its origins in eighteenth-century Rome, and it was international in scope. The etchings of the Venetian visionary, Giovanni Battista Piranesi, the functionalist ideas of the French Jesuit Abbé M.-A. Laugier, the insights into ancient styles of the German archaeologist J. J. Winckelmann and the buildings and publications of two British architects, the Scottish James Stuart and the English Nicholas Revett, exemplify the international and catholic nature of the classical revival that spread throughout the world in the eighteenth and nineteenth centuries.

Apart from Neoclassicism, the other dominant architectural style of the nineteenth century was Gothic Revival. The coexistence of the survival of Gothic building techniques with the revival of Gothic forms and decorative details is explored in this book through the writings, restorations and buildings of the proponents of this style. How the buildings of the architect A. W. N. Pugin, the writings of the critic John Ruskin, and the work of the preservationist/theorist/entrepreneur E.-E. Viollet-le-Duc were shaped by history and how they responded to contemporary technology are analysed.

The meeting of architecture and new technology that migrated from English milltowns and glasshouses to the capitals of the world is one of the most interesting phenomena of nineteenth-century architecture. This is illustrated through the works of such influential figures as Thomas Telford, Joseph Paxton and Isambard Kingdom Brunel. The crowning architectural achievements of the Industrial Revolution – Paxton's Crystal Palace in London, John

Roebling's New York Brooklyn Bridge and Gustave Eiffel's Tower in Paris – are highlighted, as they embody innovations in structure and design that spawned a progeny of modern architecture still multiplying today.

It is sometimes forgotten that the skyscraper had its origins well back in the nineteenth century, therefore its development is traced from the 'elevator buildings' of the 1870s to the glass cages of this century. The function of the high-rise building and its decoration, which have governed skyscraper design since its beginnings, are illustrated in a discussion of that most revolutionary building type since the Gothic cathedral.

Changes in domestic life produced by the Industrial Revolution found expression in the designs of tenements, flats, terraces and the so-called detached house, whose origins are also to be found in the ancient and medieval worlds. The many surviving examples of nineteenth-century housing illustrate the variety of the domestic architecture of the period, and the richness of the ideas of key designers and architects who produced it.

Finally, the interrelationships between architecture and the applied arts that characterised the Art Nouveau style towards the end of the century are explored in the works of its principal practitioners.

1 The Classical Revival

Classicism usually refers to a revival of the principles of ancient Greek and Roman art and architecture. Nineteenth-century classicism is the most recent of many revivals. There were classical revivals in Europe in the eighth and ninth centuries, in the eleventh century, and most notably in the fifteenth and sixteenth centuries – during the Renaissance. The revival of ancient architectural forms in the mid-eighteenth century in Europe and America is called Neoclassicism, and it began as a reaction to the preceding decorative and curvilinear styles of the Baroque and the Rococo.

IDENTITY AND DIRECTION

In the nineteenth century there was a full-scale classical revival that took many different forms but which kept a common feeling of identity and direction. Neoclassical architecture, like the paintings and sculpture arising from the same revival, was informed by a contemporary view of Greece and Rome as the enlightened civilisations built upon reason and respect for the laws of nature. This revival differed from former ones in its concern for an ethic which it ascribed (spuriously) to antiquity and in the way it adapted antique sources.

CLASSICAL PROTOTYPES AND CONTEMPORARY NEEDS

The wish to use classical prototypes to express contemporary needs and ideals led some architects to copy ancient models with extreme archaeological accuracy. Others united forms from antiquity with those of other periods. Still others loosened their grip on the classical past and borrowed forms from a variety of periods, as well as from contemporary sources, to solve modern problems. In doing

3

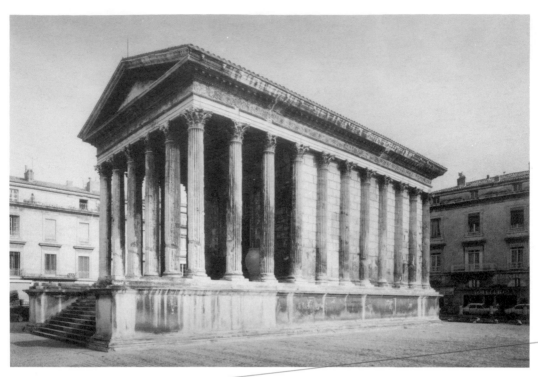

The Maison Carrée,
a Roman temple.
Late 1st century
BC, Nîmes, France.

this, they created more personal styles. Many books that expressed these ideas and approaches resulted from travels and expeditions of architects to important sites of antiquity. Such books as Stuart and Revett's *Antiquities of Athens* first volume, 1762, had enormous influence on architectural practice and the formulation of taste. Other publications dealt with theories of architecture.

FUNCTION AND PURPOSE One of the most influential Neo-classical theorists was a Jesuit priest, Abbé Marc-Antoine Laugier. In 1753, he wrote his *Essay on Architecture* introducing the premise that architecture derives from the rustic hut of primitive man (an idea that goes back to the Roman architect Vitruvius in the first century BC). As each element in the hut had a function, so each component of a building should have a purpose. This idea led eventually to the functionalist theory of architecture.

Laugier was influenced by Andrea Palladio (1508–80), one of Italy's greatest architects, who had sought to recapture the balance and symmetry of ancient architecture, following on from the classical styles of the Renaissance architects Bramante, Michelangelo and Raphael. Laugier did not advocate slavish imitation of the antique, but encouraged, as had Palladio in the sixteenth century,

4

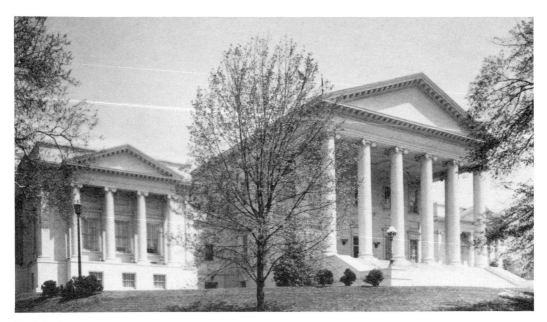

Virginia State
Capitol, Richmond,
Virginia. Thomas
Jefferson, 1785–9.

the testing and evaluation of antique forms in terms of their applicability to modern building needs, and he even supported the invention of new orders (kinds of column, for example), if the existing classical ones were inadequate to solve contemporary problems. Palladio's flexibility and pragmatic approach gave Laugier's theories a vitality that appealed to the progressive architects of his own day and continued to have influence well into the nineteenth century both in Europe and in the New World. For example, the influence of Laugier's teachings can be seen in the Bank of Pennsylvania in Philadelphia by the English architect Benjamin Henry Latrobe, which is a synthesis of classical forms and functional demands.

NEOCLASSICISM IN THE NEW WORLD

The classical revival had been introduced in America during the eighteenth century by Thomas Jefferson with his State Capitol building in Richmond, Virginia, modelled on the Maison Carrée in Nîmes. Jefferson saw this Roman temple soon after his arrival in France in 1784, when he went there to replace the ageing Benjamin Franklin as Minister to the Court of France.

A symbol of the new government in the New World, which was patterned on the Roman Republic, Jefferson's statehouse was the

first in modern times to be called a capitol (from the Latin *Capitolium*, the temple of Jupiter on the Roman Capitoline Hill) and to accommodate a republican senate. Although its design was Jefferson's own, he relied on the judgement and experience of the noted French Neoclassical architect Charles-Louis Clérisseau. Jefferson's decision to use the simpler Ionic order, instead of the Corinthian of the Maison produced a lighter exterior, more in keeping with contemporary French models, and one that combined harmoniously with the Capitol's simple fenestration. He extended the cella (the main body of the building), thereby reducing the portico from three to two columns in depth, to allow space for administrative needs inside. He used pilasters instead of the half columns of the Maison, so that the two storeys of windows would admit maximum natural light.

THE GREEK REVIVAL Assisted on the exterior by Latrobe, Jefferson's Virginia State Capitol was completed in 1796, and became a model for the new nation's official architecture. Having emigrated to the United States the year before, Latrobe moved to Philadelphia, where he built the Bank of Pennsylvania (1798) in the Greek Doric style, and the Water Works (1800) in the Greek Ionic style. These two buildings ushered in the Greek Revival style in America, which flourished in the 1820s and 1830s in the banks, civic buildings and domestic structures of such architects as William Strickland, Isaiah Rogers, and Town and Davis.

The origins of the Greek Revival have been traced to a garden temple erected at Hagley, Worcestershire, in England in 1758 by James Stuart. Nicknamed 'Athenian' Stuart because of his architecture in the Grecian style and his investigation of ancient Greek architecture with Nicholas Revett resulting in their famous *Antiquities of Athens*, Stuart's temple at Hagley was a faithful replica of an ancient Doric temple.

While a fashion for Greek architecture emerged by the latter half of the eighteenth century in Europe, it was such architects as Ledoux and Boullée in France and Sir John Soane in England who first recognised the simplicity of Greek architecture, which reduced structure to its essential geometrical elements, and that it could have applications to contemporary design.

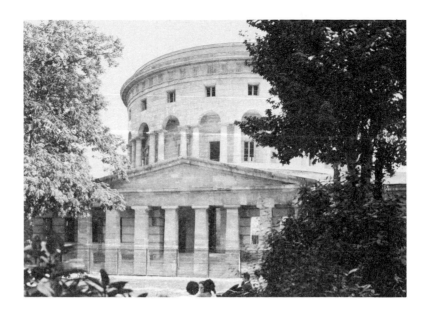

Barrière de St-Martin, Place de Stalingrad, Paris. Claude-Nicolas Ledoux, 1784–9. One of several toll-houses built by Ledoux as 'Architecte du Roi'.

THE VISIONARY TRADITION OF LEDOUX AND BOULLÉE

The late eighteenth century was a period of mixed influences that produced extraordinary hybrids of style. Significant examples of this hybrid sensibility are found in the works of Claude-Nicolas Ledoux and Etienne-Louis Boullée, the period's foremost 'visionary' architects, so-called because of the fantastic and utopian character of some of their designs.

Ledoux studied in Paris with J.-F. Blondel, Clérisseau's teacher, and was attracted to Italian architecture (even though he did not travel to Italy) and drawn to the spatial and formal fantasies of Piranesi's engraved views. Among his major commissions as 'Architecte du Roi' (appointed 1773) were the theatre at Besançon, the buildings of the Royal Saltworks at Arc-et-Senans and the *barrières* (toll-houses) of Paris.

The Barrière de St-Martin on the Place de Stalingrad in the La Villette district of Paris is one of his most successful: influenced by Palladian principles and deriving ultimately from Andrea Palladio's Villa Rotonda in Vicenza, its purely architectural form, suppression of decorative detail, and Piranesian proportions distinguish it from its predecessors.

A simple and stark central square block, from which radiate classical porticoes (forming a Greek cross) with low-pitched pediments supported by massive unadorned square piers, hugs the

7

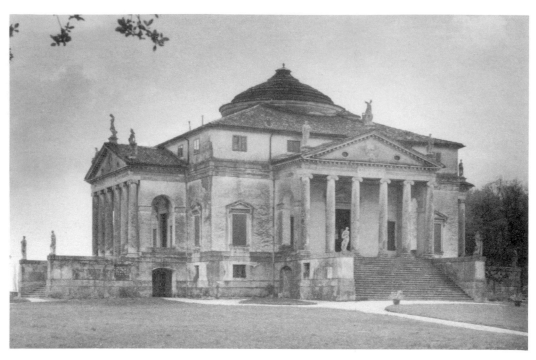

earth and serves as a mighty stone base for a giant masonry cylinder that rises from its centre, its circumference contained by the outer walls of the central block.

The cylinder is supported by an Italianate arcade defined by paired Doric columns. Above each keystone, a small rectangular attic window breaks the horizontal area beneath a Doric frieze under a projecting cornice. The skeleton-like open arcade separates the cylinder from its base, which makes it appear to hover over the massive central block below.

These innovations embodied in Ledoux's Barrière de St-Martin, in which ornament is reduced to a minimum and the underlying architectural structure is expressed simply and clearly, are also found in the so-called 'visionary' designs of the period, exemplified in A Project for a Memorial to Isaac Newton conceived by Boullée. The project, never realised, was to have consisted of a celestial globe, pierced above to create the illusion of stars from within the sphere, with the space inside empty except for the lifesize sarcophagus of Newton, beneath the enormous man-made sky and stars above, symbolising the universe. The monument is emblematic of Newton's discovery of gravity and his laws of motion that govern the universe. In suggesting the immeasurability of the

8

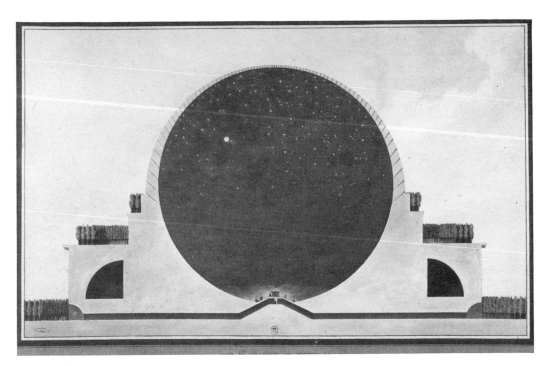

A Project for a Memorial to Isaac Newton, to have been 150 metres high but never executed. Etienne-Louis Boullée, 1784.

infinite through the manipulation of scale and space, Boullée underscores the significance of Newton's achievement and charges the otherwise abstract architectural forms with cosmic symbolism.

The visionaries made designs (many not carried out) for a wide range of purposes. For example, Ledoux designed a House of Sexual Education whose plan was a phallic outline, and a coopery made of barrel-like shapes. Among ideas thought to be too visionary or too literally symbolic to be executed, was J. J. Leque's whimsical stable in the form of a cow! Showing the purpose of a building mimetically, by 'miming' its purpose (called *architecture parlante* in the eighteenth and nineteenth centuries) has a long pedigree. The tradition looks back to Roman bakers' tombs in the shape of ovens and ahead to twentieth-century refreshment stands shaped like ice cream cones.

The fantasies of Ledoux, Boullée and their followers fertilised the Neoclassical idiom in a way not fully appreciated in their own day but which was to have far-reaching effects on succeeding generations of architects. The twentieth century picked up many of the ideas of the 'visionaries' of the eighteenth and nineteenth centuries and interpreted them anew.

Both Ledoux and Boullée (who actually built very little) exerted

9

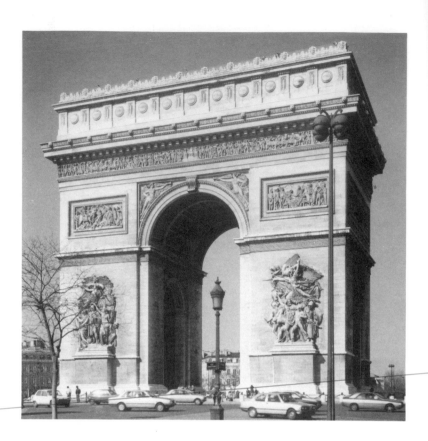

Arc de Triomphe de l'Étoile, Paris. Jean-François-Thérèse Chalgrin, 1806–35.

great influence on the visionary tradition not as much through their buildings as through their students, followers and writings. Ledoux published *L'Architecture Considérée sous le Rapport de l'Art, des Mœurs et de la Législation* in 1804, and Boullée's *Treatise on Architecture*, not published until modern times, injected new spirit in the visionary tradition in the twentieth century.

The influence of Ledoux and Boullée on the official architecture of France is reflected later in the giant Arc de Triomphe de l'Etoile by Chalgrin. The great size of the arch reflects the megalomania of rulers and of visionary architects, and the broad surfaces display their use of geometric forms; the grandeur is further enhanced by the reliefs, which express the highest qualities of Romantic sculpture by Rude, Etex and Cortot.

DURAND AND HIS FUNCTIONALIST THEORY

Among Boullée's most influential students was his draughtsman Jean-Nicolas-Louis Durand, architectural theorist and engineer

10

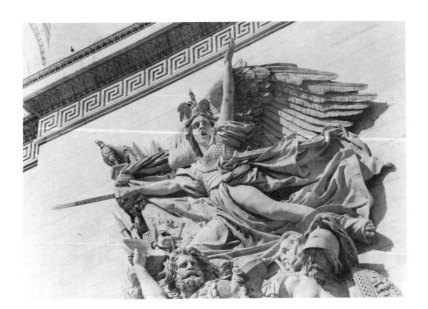

The Marseillaise
(The Departure of
the Volunteers of
1792), Arc de
Triomphe de
l'Étoile, Paris.
François Rude,
1833–6.

who became Professor of Architecture at the new Ecole Polytechnique in 1795. Durand taught that the rational composition of Neoclassical forms was compatible with contemporary technology, and his lectures at the Ecole were published as *Précis des Leçons d'Architecture*, which became the basic text for architects and the most influential treatise on architecture in the first half of the century. In addition to perpetuating the ideas of the visionary architects, Durand presented a functionalist theory of architecture reminiscent of Laugier's ideas, except that Durand's was based on two psychological principles: man's rejection of pain and attraction to pleasure. Durand reasoned that because architecture is made by man for man, its success must be measured by how well and how economically a structure achieves the purpose for which man built it. He felt that too great an emphasis had been placed on making buildings pleasing to the eye by means of decoration.

NEOCLASSICISM IN RUSSIA

In Russia, too, the classical revival resulted in some distinguished and beautiful buildings, many of which can still be seen today in Moscow and particularly St Petersburg. The Neoclassical style had become popular in Russia in the 1770s, largely through the work of architects imported from France, Italy and Scotland. In 1773,

Catherine II commissioned Clérisseau, whose drawings of ancient Rome she collected, to design a house for her based on ancient models, and the Scottish Neoclassical architect Charles Cameron designed an Ionic gallery (1782–5) for the Empress's palace to exhibit the ancient marble statuary she had collected. In 1780, Catherine brought in the Italian architect Giacomo Quarenghi, whose works include an English palace (1781–91) at Peterhof in Palladian style, numerous parks and a riding school (1800–4) in St Petersburg with an Etruscan portico. Other Italian architects active in Russia at the end of the eighteenth and the beginning of the nineteenth century included Vincenzo Brenna and Giovanni Battista Gilardi.

Russian architects active at this time who adopted the Neoclassical style were Matvei Federovich Kazakov and Ivan Egorovich Starov. Quarenghi's influence can be noted in the refined classical style of Kazakov's Barysnikov Palace (1797–1802) in Moscow, and Starov embraced the Neoclassical style in his Tauride Palace (1783–8) in St Petersburg.

At the beginning of the nineteenth century, two Russian architects distinguished themselves in the Neoclassical style, Andrei Nikiforovich Veronihin and Adrian Dmitrievich Zakharov. Veronihin's major work was the Cathedral of the Virgin of Kazan in St Petersburg (1801–11). It shows a combination of influences drawn from St Peter's and the Pantheon in Rome, and the Panthéon in Paris. Zakharov was inspired by the designs of Piranesi, Ledoux and Boullée for his major work, the New Admiralty in St Petersburg (1805–15). Zakharov's gargantuan coffered arch of the Admiralty's entrance is reminiscent of Piranesi's prison drawings, and the monumental temple above the arched entrance evokes associations with Ledoux's and Boullée's visions of cenotaphs, temples and civic halls.

Ledoux's influence was even more pointed in St Petersburg's Bourse (Stock Exchange, 1801), a temple-like building with Tuscan columns, and the Mausoleum of Paul I (1806–10) in Pavlovsk in the style of a Doric temple. Both are by Thomas de Thomon (1760–1813), who was born in Switzerland, studied in Paris and emigrated to Russia, where he became court architect to Alexander I in St Petersburg.

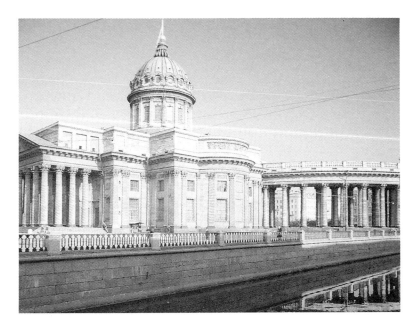

Cathedral of the
Virgin of Kazan, St
Petersburg. Andrei
Nikiforovich
Veronihin,
1801–11.

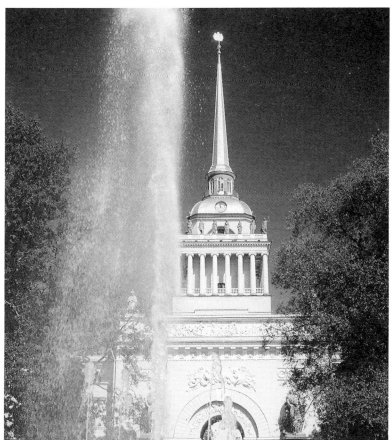

New Admiralty
Building, St
Petersburg. Adrian
Dmitrievich
Zakharov, 1805–15.

Another émigré contributed greatly to Russian architecture during the nineteenth century's first decades. The French architect Auguste Ricard de Montferrand (1786–1858) combined modern technology with the Neoclassical style in his great dome framed in iron for St Isaac's Cathedral (1847–57) in St Petersburg. And the Italian architect Carlo Rossi designed palaces, theatres, streets, squares and triumphal arches in the heyday of Russia's interest in the Neoclassical style.

The leading Russian architect of the last phase of Neoclassicism was Vasili Petrovich Stasov, whose Moscow Gate (1833–8), the triumphal arch in St Petersburg, drawn from a design by Quarenghi, is among his most notable achievements.

Buildings very similar in style to the Neoclassical architecture of St Petersburg are to be found in Sweden and Finland, a Grand Duchy of Russia in the early part of the nineteenth century. In Helsinki there is still to be seen a splendid group of colour-washed Neoclassical buildings (1816–40) in the 'Finnish Empire' style as it was called, by the Finnish architect Carl Ludwig Engel.

NEOCLASSICAL INFLUENCE IN GERMANY

The Neoclassical and visionary ideas and practices alive in France and England in the late eighteenth century had far-reaching influence. In Germany, they are exemplified in Friedrich Gilly's competition design for a monument to Frederick the Great, 1797. The design consists of a great funerary precinct with a sarcophagus for the Prussian king at the centre. Gilly's Greek Doric temple is raised acropolis-like on a high platform. Piranesi's influence can be seen in the tunnel-vaulted triumphal arch leading into the precinct, and the simplified forms of Greece and Rome recall Boullée's visionary drawings of cemeteries and cenotaphs, Ledoux's toll-houses of Paris and his theatre at Besançon.

Karl Friedrich von Schinkel (1781–1841), later to become one of Germany's greatest architects, studied under Gilly and was greatly influenced by his master's free and original interpretation of classical forms. Also a painter of panoramas and dioramas and a stage designer, Schinkel rose to become head of Public Works. His

The Grand Hall,
Schauspielhaus
(Playhouse), Berlin.
Karl Friedrich von
Schinkel, 1819–21.

principal buildings were executed between 1816 and 1830, and reflect a combination of classicism and functionalism. For example, his Schauspielhaus (Playhouse) in Berlin with Ionic portico reveals the internal shapes of the building through a closely knit grid of masonry piers, cornices and entablatures expressed as a design of verticals and horizontals that holds the building compactly within a series of interrelated cubes.

SOANE AND NASH: TWO GREAT ENGLISH INNOVATORS

SIR JOHN SOANE: AUSTERITY AND ECLECTICISM Unlike Gilly, who never saw Italy, Sir John Soane (1753–1837) spent three years there and may have known Piranesi personally; he was certainly influenced by the Italian artist's engravings. There was a new kind of austerity in Soane's work which is evident in his Bank of England, begun in 1788, when he was appointed Surveyor to the bank. The shallow domes and the rotunda, the structural simplicity of its spaces flowing over into one another and the reduction of

15

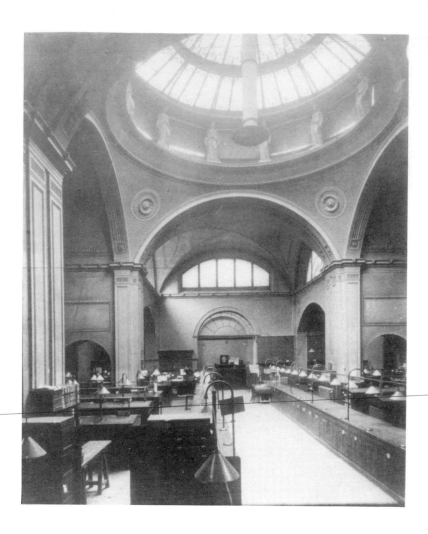

Consols Office,
Bank of England,
London. Sir John
Soane, 1794.

ornament to grooves and incised mouldings best express Soane's passion for elementary geometric shapes, replacing the decorative curves of the Rococo style.

Soane's penchant for planes rather than masses, already clear in his Bank of England building, is even more explicit in his own house, No. 13 Lincoln's Inn Fields in London (1812–13), in which the romantic and picturesque element of his work is obvious. Inside, the complicated floor levels, ingenious top-lighting and hundreds of mirrors positioned to suggest receding planes, all contribute to one of his most innovative designs.

Soane's incorporation into the house facade of Gothic brackets from Westminster Hall, and the curiously medieval features in his Pell Wall House, Staffordshire (1822–8), reminiscent of Vanbrugh, are forceful reminders however that, in contrast to his austere

Lincoln's Inn
Fields, London.
Sir John Soane,
1812–13.

modernity, some of his work is a very individual mixture of
eighteenth-century romanticism and nineteenth-century historic-
ism. That antiquarian sensibility is also found, for example, in
Gilly's accomplished drawings of medieval castles, most notably the
Marienburg in West Prussia, published in 1794.

JOHN NASH: FREEDOM AND FORMALITY Almost an exact
contemporary of Sir John Soane, John Nash (1752–1835), the
master of the picturesque in England, came on the scene at a time
when eclecticism reigned. In tempo with the times, Nash built in
every style. His own town house was classical and his country house
Gothic. He built Blaise Hamlet near Bristol (1809) in a rustic Old-
English cottage style; and he worked on the Brighton Pavilion in
'India Gothic', as the style was then called.

The same picturesque combination of freedom and formality
that characterised Nash's houses made him an inspired town plan-
ner. His greatest work was Regent's Park, with its terraces and
villas, and old Regent Street in London (from 1811), built in a
wholly classical style. The wish and capacity to unite landscape with
housing, which Nash pioneered in Regent's Park, foreshadowed

17

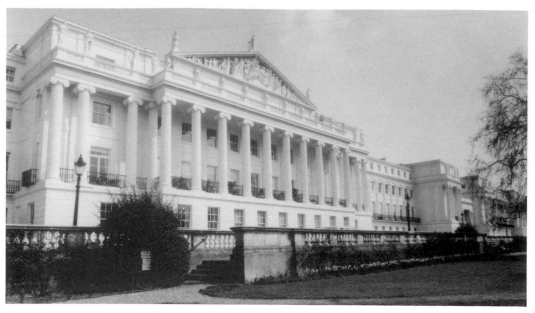

Cumberland
Terrace, Regent's
Park, London. John
Nash, 1812–27.

the ideas of the Garden City Movement in the twentieth century
(Letchworth, for example). In Regent's Park the landscape 'garden'
is surrounded by an arrangement of huge terraces of private houses
of grand proportions (of which the facades have been restored but
which are now used as offices) and faced with painted plasterwork
(a medium Nash had pioneered in the 1780s).

The traditions of homogeneous terrace design go back to the
early eighteenth century. These terraces (for example, those in
London and Bath) had been designed to form squares, with a
garden in the middle and they had reflected, in John Wood the
Elder's hands, a Palladian uniformity. His son, John Wood the
Younger, broke from this convention with his design for the Royal
Crescent in Bath (1767–75) where the grand sweep of houses faces
a broad lawn sloping down the hillside, opening onto wide views
beyond. Nash's Regent's Park Terraces took this development even
further.

BUILDING FOR CIVIC NEEDS

In spite of Soane's, Gilly's and Nash's innovations and their vision
of architecture's potential to draw on the past to produce new
solutions for the present, the new ruling class, made up of mainly
manufacturers and industrialists, preferred their buildings in the

18

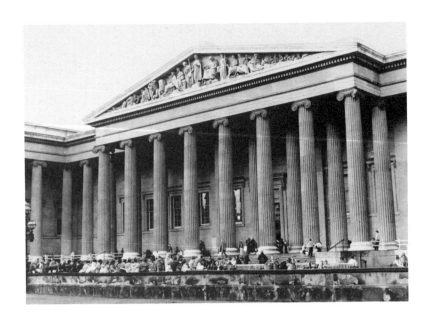

British Museum,
London.
Robert Smirke,
1823–46.

familiar historical styles. Living and working in buildings that were reminiscent of ancient Greece and Rome, for example, provided the patron with an identity associated with those great civilisations.

With the continuing developments of the Industrial Revolution into the nineteenth century, cities grew and with them the need for a wide range of new building types to fulfil governmental and civic functions. These included railway stations, museums and galleries, libraries, theatres, concert halls, banks, exchanges, department stores and office buildings.

Innovations in hospital design, for example, provided accommodation for patients with different kinds of diseases, new plans for prisons revolved around modern notions of controlled recreation, and the 'ferrovitreous galleria' (iron and glass gallery) proved to be as serviceable for museums and libraries as for the first modern department store, the Bon Marché in Paris, that opened in 1876. This department store was copied throughout the world. One of its most impressive offspring is the shop Fraser's on Buchanan Street in Glasgow, of 1885. Complete with multi-storied gallery, and decorative plasterwork concealing cast-iron columns, its vaulted and glazed skylight gave it the nickname 'Commercial Crystal Palace'.

A building that combines the new social function of architecture as well as the historicism of the nineteenth century is Robert Smirke's British Museum in London, begun in 1823. While the Ionic Order of ancient Greece is carefully replicated in the

19

museum porticoes, its overall grand scale, designed to accommodate an enormous collection, has little in common with the architecture of fifth-century Athens.

The railway station has been called the nineteenth century's most distinctive contribution to building types. From the first stations built in Britain – the Manchester Liverpool Road and Liverpool Crown Street Stations – opened in 1830, the stations were like classical town houses, built two storeys high, a formula that set the style for many stations that followed. But the really great examples of railway stations were built in the second half of the century.

Particularly in the north of England the newly expanded industrial cities such as Leeds and Manchester used their prosperity to build large and impressive Town Halls, expressing a feeling of civic worth and dignity through their use of massive Greek Order porticoes and pediments.

SEMPER'S THEORY OF THE ORIGINS OF ARCHITECTURE

The leading German architect from the 1830s to the 1860s was Gottfried Semper, who worked under two Germans practising in Paris at the time, Franz Christian Gau and Jakob Ignaz Hittorf. Gau was an Egyptian scholar and architect who had also studied in Rome, where he had been a friend of the Nazarenes, a group of German painters who revived an interest in Italian Quattrocento painters and medieval German art. Hittorf had trained in Paris under Percier and Bélanger. Hittorf's work in ferrovitreous construction (influenced no doubt by Bélanger's glass and iron dome for the Halles aux Blés in Paris) and his studies of the ancient Greeks' use of polychromy, in turn influenced Semper, as is shown by his work on some sections of the Great Exhibition in London of 1851 and his published observations on the use of polychromy in Greek architecture.

In blending the rectilinear nature of Renaissance forms with the exuberance of Baroque, Semper's Dresden Opera House (1838–41, redesigned 1871 following partial destruction by fire) was one of his most important buildings. *Der Stil*, his treatise on craft and

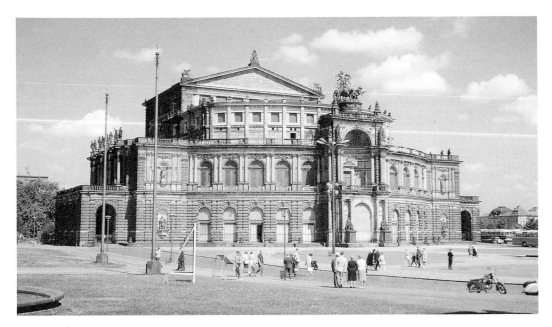

Dresden Opera
House. Gottfried
Semper, 1838–41;
redesigned 1871.

design, relating the arts to industry and analysing the origins of architecture, even though never completed, established Semper as a leading theorist of the nineteenth century and continued to influence architects into the twentieth century.

Reminiscent of Laugier's ideas, Semper's view was that architecture had originally emerged from the hearth, man's first social gathering place. The sub-structure of a building derived from the first platform for the hearth, the supporting frame and roof from the earliest protective covering for the hearth, and the enclosing walls from the primitive shelter for the people gathered on the platform around the hearth. Semper went further and identified the hearth with the development of ceramics and metallurgy, technologies that played pivotal roles in the most advanced architectural developments of the nineteenth and twentieth centuries.

THE EMPIRE STYLE

The style which came to dominate in France in the early years of the century, and which became the 'official' style, was the Empire Style, so called because it was developed under Napoleon I's Empire (1804–14). It was formulated principally by Napoleon's favourite architect, Pierre-François-Léonard Fontaine and his partner Charles Percier.

One of their best examples in this Empire Style is the Rue de Rivoli in Paris (facing the Tuileries Gardens) with its elegant facade of spare classical forms. An open arcade is supported by rectangular piers and detailed by plain moulding at the imposts, keystones and relieved archivolts. Above unadorned spandrels, continuous corbel tables support metal balustrades (a motif repeated at the third storey), which divide the arcade from the three floors above it and the crowning mansard. The effect of an immaculate continuous facade is created.

This construction was part of Napoleon I's major urban planning project for Paris. (A much more revolutionary transformation was to be effected during the 1860s by Baron Georges-Eugène Haussmann, under Napoleon III, which linked such great monuments as the Arc de Triomphe with the old city of Paris by way of expansive boulevards meeting at strategically positioned *ronds-points*, traffic circles, or roundabouts).

The First Empire Style is, however, best represented in the interior decorations that Fontaine and Percier developed in remodelling Napoleon's residences at Saint-Cloud, the Château at Fontainebleau and the Tuileries Palace; it is rich and decorative and characterised by a graceful curvilinear elaboration of classical and oriental designs. Further distinguished by its elegantly and flatly carved and modelled surfaces in brass, dark mahogany, ivory and gold, the style's popularity throughout Europe was increased by the publication of Fontaine's and Percier's designs in *Maisons et Palais de Rome Moderne* and *Recueil de Décorations Intérieures*.

THE SECOND EMPIRE STYLE The style that developed under Napoleon III had an entirely different character. It is best exemplified in the pavilions for the New Louvre (1852–7) designed by L.-T.-J. Visconti (1791–1853) to connect the Louvre and the Tuileries, and modified by H.-M. Lefuel (1810–80) when Visconti died. Elaborately carved dormers projecting from the high mansard roofs are ornate and three-dimensional. Lefuel's lush treatment was imitated throughout Europe as well as in the New World, and the proliferation of multiple mansards and pavilioned facades continued long after the eighteen years' duration of the Second Empire.

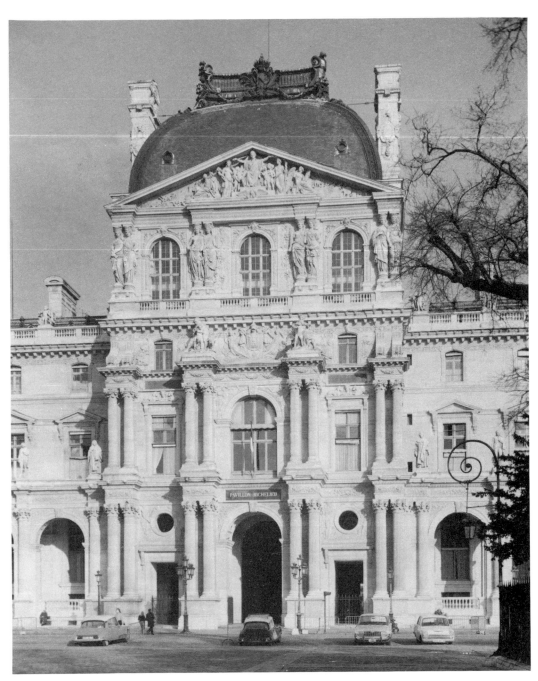

The New Louvre,
Paris. L.-T.-J.
Visconti and H.-M.
Lefuel, 1852–7.

Several hotels in England were built on this mansarded French model well into the 1890s: for example the Carlton in London (1897) by H. L. Florence. Perhaps the most notable example of the resort hotel type in the Second Empire mode is the Cliff (now the

Grand) at Scarborough in Yorkshire, built by Cuthbert Brodrick in 1863–7. Remarkable ensembles of the style which have survived in part in London are the terraces of Grosvenor Place (1867) and Cambridge Gate (1875).

In the United States, the French-trained architect Detlef Lienau introduced a feeling for the Second Empire style with his design for the mansarded Hart M. Shiff house in New York City (1849–50). And when Richard Morris Hunt, who studied with Lefuel and assisted him on the New Louvre, returned to New York City in 1855, he built numerous town houses along Fifth Avenue for the wealthy, in the French tradition. This Second Empire style was enormously popular for free-standing houses outside the cities as well. They were symmetrically and tightly planned houses built of wood, often in colours to simulate stone. The mansarded style was also popular in the 'wild west' of the United States, for example the Vendome Hotel in Leadville, Colorado, which is still in use.

Notable examples of the Second Empire style still stand in such European centres as Amsterdam, Brussels, Budapest, Frankfurt, as well as Berlin, where the German architect, G. H. Friedrich Hitzig (1811–81), who studied in Paris and was a former assistant of Schinkel, built a few distinguished mansarded houses that breathe the spirit of Paris.

2 The Gothic Revival

Gothic forms of building such as vaulted halls, long galleries, towers and battlements, along with Gothic building techniques of skeletal construction, masonry, glazing and tracery had survived in Europe, especially in the countryside, since the Middle Ages. With an increased interest in medievalism, in the eighteenth century, however, builders in England began to select Gothic forms not for their functional purposes, but for their historical associations with the Middle Ages and for their decorative character. This self-consciousness in reviving Gothic forms for non-functional and fanciful purposes resulted in what has become known, during the second half of the eighteenth century, as the Gothick (with a 'k') style (Georgian Gothic), usually Rococo in spirit, to distinguish it from the Victorian Gothic Revival of the nineteenth century.

The Gothick Revival of the eighteenth century had many different aspects. Several of these are well illustrated in Horace Walpole's Strawberry Hill, the villa he had begun transforming around 1750. Walpole was guided by seventeenth- and eighteenth-century engravings, as well as actual buildings of the Middle Ages and his sources can be readily traced to such buildings as Westminster Abbey and the cathedrals of Rouen and Canterbury. The style, once adopted for domestic architecture and characterised by a liking for mixing 'correct' detail drawn from an extraordinary range of sources, became extremely popular.

The inventive spirit with which Walpole transformed Strawberry Hill contributed, likewise, to the literary romances of the time. His Gothick novel, *The Castle of Otranto*, started a new vogue for themes of terror, mystery and exoticism set against a backdrop of the dungeons, keeps and crenellations of medieval castles. All this had curiously little in common with the decorative sense of Strawberry Hill but it shared a common source in medieval architectural forms.

The demand grew for Gothick romances of mystery and intrigue played out against medieval settings; examples of novels of this kind

that enjoyed great popularity are Ann Ward Radcliffe's *The Mysteries of Udolpho* and Clara Reeve's *The Old English Baron*. The literature, in turn, exerted an influence on the architecture of the period. As the romance became more historically sophisticated in such works as Sir Walter Scott's *Ivanhoe*, *Kenilworth* and *The Talisman*, architects turned to a greater variety of literary sources for inspiration. Themes from Richard Wagner's operas partly inspired Ludwig II's Schloss Neuschwanstein in Bavaria. The palace's interior decorations carry Wagnerian motifs.

Castles as private residences abounded from the middle of the eighteenth century, along with a profusion of garden ruins, broken columns, follies and the like, and this popularity continued into the nineteenth century. One could perhaps draw a parallel between this taste for the incomplete, for the ruin, with the interest in the sculptural fragment at the same period, both phenomena showing a fascination with the past.

FONTHILL ABBEY AND THE PICTURESQUE

The largest and most remarkable of the neo-medieval residences at the turn of the century was Fonthill Abbey, designed by James Wyatt. It was the mansion of William Beckford, antiquarian and also the author of a bizarre oriental romance, *Vathek*. Begun in 1796, as a kind of stage set for picnics, Beckford soon took his 'folly' seriously and had it constructed as his residence. It was named for its site, Fonthill Gifford in Wiltshire near his birthplace, Salisbury. Beckford had already enclosed much of the estate with a high fence to keep out hunters; this added to the sense of mystery. Sublimely situated at the top of a hill, the Abbey's elegant octagonal tower gave marvellous views of the surrounding countryside.

Of special importance in the eighteenth and nineteenth centuries was the picturesque aspect of a structure's silhouette, that is, how it looked to the spectator against the sky and grounds around; Fonthill's tall slender tower was a marvel that captivated the public's imagination and appealed to contemporary artists, who painted many views of it. The view from the northwest was found to be the most picturesque, therefore most often represented, showing the

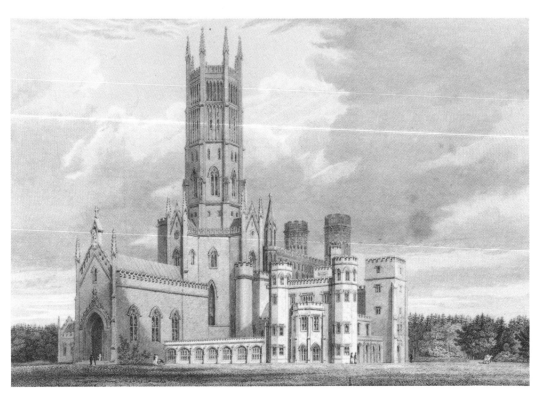

Fonthill Abbey, near
Salisbury, Wiltshire,
James Wyatt's
spectacular
combination of the
picturesque and the
sublime, begun in
1796 and later
destroyed by fire.

main entrance (west facade) and soaring tower flanked by a long
gallery to the north and a gallery, cloister walk, fountain court and
drawing room to the south. Its central plan with projecting arms,
cloister and grand crossing tower, combined picturesque and
sublime features within an ecclesiastical format that struck awe into
the bosoms of its spectators. With the collapse of the tower in 1825,
due to faulty construction, Fonthill Abbey became a ruin in its own
time and an object of great fascination to the travellers who came
from far away to see it.

The 'picturesque' had its origins in eighteenth-century England,
where the term was used to describe a landscape or building that
reflected the romantic view of the past as portrayed, for example, in
paintings by Claude Lorrain and Gaspard Poussin. By the
nineteenth century, the term came to mean an eclectic style
designed to evoke some kind of nostalgic feeling for the past. John
Nash's favourite picturesque mode, for example, was the asym-
metrically towered Italian villa exemplified at Cronkhill (1802). In
addition to his many crenellated mansions Nash applied the pic-
turesque principle of asymmetry to urban development, as des-
cribed in chapter 1.

27

One well-known traveller, the American actor Edwin Forrest, was inspired to build for himself and his English wife his own Fonthill in a picturesque landscape garden setting along the banks of the Hudson River in New York. Although Forrest's Fonthill Castle, built by Thomas C. Smith still stands, tragic irony veils it. The Forrests were separated (and later divorced) before it was finished. In the year it was completed (1852), Andrew Jackson Downing, pioneer of the picturesque movement in America and the country's leading writer on landscape gardening, was drowned near the east bank of the Hudson in a boat accident just a stone's throw from the foot of the castle. That same year, Lillie Martin Spencer, the American domestic genre artist, painted *Reading the Legend* from her studio across the Hudson River facing Forrest's castle. The silhouette, massing of towers and landscape garden, set across a river bank from the two young lovers, are strikingly similar to Forrest's Fonthill Castle. Her painting is a fitting tribute not only to Downing and Fonthill Castle, but also to the Gothic Revival and the picturesque in America.

BARRY: CLASSICAL AND GOTHIC

Another architect who combined picturesque and classical elements was Sir Charles Barry. The most important commission of his career and a landmark in the history of public buildings is the Houses of Parliament in London. Barry, a versatile and leading early Victorian architect, built in many 'revival' styles. By 1834 he had travelled extensively, studying the architecture of France, Italy, Greece, Turkey, Egypt and Palestine. On the night of 16 October, when the old Palace of Westminster burned, Barry witnessed the spectacle from the Brighton coach while returning to London.

It was decided to rebuild in the style of 'ancient English architecture', and a competition was held to select an architect. The growing preference for the picturesque, with its early eighteenth-century origins in England, over the classical mode was expressed in the Parliamentary Committee's decision to rebuild in either 'Gothic' or 'Elizabethan'. The candidates complained that the terms were not sufficiently specific. Nonetheless, ninety-seven

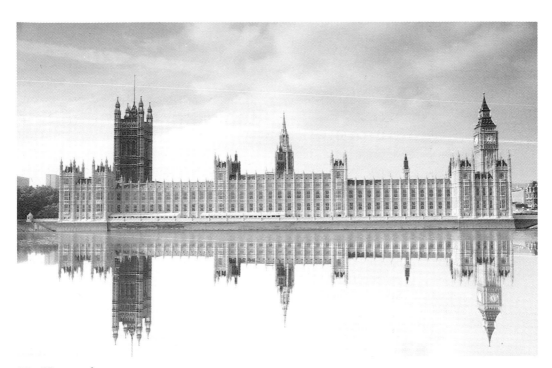

The Houses of Parliament, London, river facade. Sir Charles Barry and A. W. N. Pugin, 1835–60.

candidates submitted 1,400 drawings. Barry's plan was accepted in 1836. Construction began in 1839, and was completed by Barry's son (Edward Middleton Barry) in 1870.

Barry's buildings are the first major public monument in the Gothic style. They mark an epoch-making shift from the forms of Neoclassicism, while retaining some of the visual characteristics of the antique. His choice of the Perpendicular style presents a classical logic and rhythm especially noticeable in the regular repetition of straight verticals and horizontals along the river front facade. The long, low rhythm of repetitive detail and the regularity of the fenestration whose reflection in the Thames is, as the mood of the river changes, by turns still and shimmering, shows a remarkable visual and structural homogeneity. He insisted on keeping the building close to the Thames, and 'the excellence of its river front' was hailed in its own day as 'eminently successful in effect'.

Although the plan of the new complex was Barry's, the massing of space around a central octagon was indebted to Fonthill Abbey, and the great clock tower was A. W. N. Pugin's design. The tower houses Big Ben, the thirteen-tonne bell constructed from patterns by Edmund Beckett. It was named after Sir Benjamin Hall, First Commissioner of Works, who was called 'Big Ben'. The nickname

was extended to the great clock itself, also designed by Edmund Beckett.

Pugin also designed the exterior Gothic details as well as the interior furnishings for the Houses of Parliament. A gifted draughtsman, Pugin had previously designed Gothic-style buildings, furniture and stage sets, which were already influencing the decorative arts of the time, notably the ironwork of John Hardman and the fashionable tile designs of Herbert Minton.

The Houses of Parliament are a blend of classical regularity and Gothic decoration, an innovative combination of England's Gothic heritage and the classical style of the Renaissance and the ancient worlds. Here, expressed in the work of Barry and Pugin, is a demonstration of how superlatively compatible the two styles can be.

PUGIN AND THE GOTHIC REVIVAL CHURCHES

The next phase of the Gothic Revival was characterised by buildings that in their design showed how they had been constructed. This mature phase of the Gothic Revival was brought about largely by the work of Pugin, who felt that the structural principles and methods that guided the medieval builders should be reflected in the Revival buildings. The churches he built, as well as his highly influential publications (*The True Principles of Pointed or Christian Architecture* and *An Apology for the Revival of Christian Architecture in England*) show a new grasp of the interrelationships between Gothic style and structures that anticipate modern-day functionalism. These publications resulted, to a large extent, from his lectures at Oscott, a Roman Catholic Seminary in Birmingham, where he was appointed Professor of Ecclesiastical Art in 1837, after his book *Contrasts* had earned him great fame.

In *Contrasts; or, a Parallel Between the Noble Edifices of the Fourteenth and Fifteenth Centuries, and Similar Buildings of the Present Day; shewing the Present Decay of Taste* (1836), Pugin ingeniously compared on the one hand old and new buildings that represented for him the ideal of a revered and virtuous Catholic past and on the other the degenerate structures of a brutal present. A convert to

opposite
A page from
Contrasts by
A. W. N. Pugin,
1836.

30

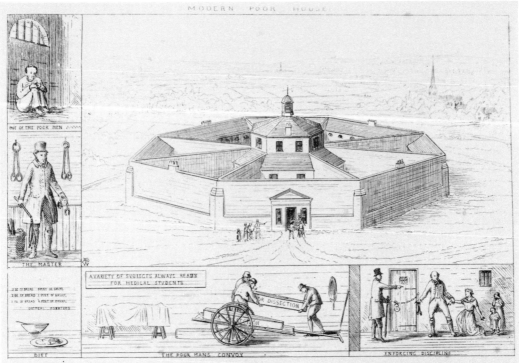

MODERN POOR HOUSE

ONE OF THE POOR MEN

THE MASTER

DIET

A VARIETY OF SUBJECTS ALWAYS READY FOR MEDICAL STUDENTS

FOR DISSECTION

THE POOR MANS CONVOY

ENFORCING DISCIPLINE

CONTRASTED RESIDENCES FOR THE POOR

ANTIENT POOR HOYSE.

ONE OF THE POOR MEN

THE MASTER

DIET

THE POOR BROTHERS CONVOY

ENFORCING DISCIPLINE

31

St Giles' Church,
Cheadle,
Staffordshire.
A. W. N. Pugin,
1840–6.

Roman Catholicism, Pugin thought that Gothic churches in the Decorated Style of the late thirteenth and early fourteenth centuries best expressed the spiritual and religious ideals in which he believed. His ideas called for a new richness in decoration that was costly; consequently, he encountered some resistance, but this was

overcome by the appeal of his work to such influential groups as the Cambridge Camden Society.

St Giles' at Cheadle in Staffordshire, built for Lord Shrewsbury, is based on the English parish church plan of the fourteenth century, although larger: a tower and spire above a steeply pitched roof covering the nave, aisles and deep chancel. The interior, characteristic of Pugin's Decorated Style, is resplendent with colour, rich decoration, and an exquisitely wrought chancel screen. The brasswork throughout is by John Hardman, whose craftsmen Pugin had instructed at Oscott. Pugin conceived of his churches as settings for ritual, an aspect of his art that was inspired in part by his early work in theatre set design and one that satisfied contemporary taste. By contrast, less costly Greek temple designs had been satisfactory for the simpler liturgy of the eighteenth century, which focused on the pulpit and the reading desk, and which therefore did not require deep chancels or an abundance of rich decoration. The biggest cost of these had been the portico with its high columns and pediment.

THOMAS RICKMAN It was Thomas Rickman who introduced the categories of Gothic style that are still in use today: Early English (late twelfth to late thirteenth century), Decorated (late thirteenth to second half of fourteenth century), and Perpendicular (early fourteenth to late fifteenth century), also called First Pointed, Second Pointed and Third Pointed (or, Early, Middle and Late Pointed). He set these out in a series of lectures published in London in 1817 as *An Attempt to Discriminate the Styles of English Architecture*. Called the 'Quaker Quack', a reference to his having been a Quaker pharmacist and businessman turned architect, Rickman was in the forefront of progressive building practices. His St George's, Birmingham, in the revived Perpendicular style, was a respectable contribution to the great building campaign initiated in 1818 by the Church Building Society. Over 200 churches were built, called Commissioners' Churches, to satisfy the needs of fast-growing population centres brought on by the industrial changes of the early nineteenth century. As part of the same changes, Rickman had already pioneered the use of iron in his Gothic churches in Liverpool in 1813.

St Mary's Church,
Brewood,
Staffordshire.
A.W.N. Pugin,
1842–4.

THE CAMBRIDGE CAMDEN SOCIETY In 1837, a group of like-minded students at Cambridge, led by John Mason Neale, Edward Jacob Boyce and Benjamin Webb, began visiting churches to study their architecture. By 1839, their number had grown to thirty-eight and they had organised themselves into the Camden Society (later called the Ecclesiological Society), named after the renowned sixteenth-century antiquarian William Camden. The members dedicated themselves to the study of Gothic architecture and ecclesiastical antiquities, and their activities became known as the 'Cambridge Movement'. The Oxford Society for Promoting the Study of Gothic Art, associated with the Church of England and known as the 'Oxford Movement', had been formed a little earlier.

The Camden Society found Pugin's architecture, which called for extensive decoration, especially suited to its devotional ends, even though his outspoken Roman Catholicism annoyed some members. Through their pamphlets and journal, the *Ecclesiologist*, they contributed to the acceptance and popularisation of Puginian Gothic, which reigned until the 1850s, when it was absorbed into the broader High Victorian mode of 'constructional polychromy'.

34

All Saints' Church, London. William Butterfield, 1849–59.

WILLIAM BUTTERFIELD This use of polychromy can best be seen in the work of William Butterfield, an ardent follower of Pugin. From the beginning of his practice as an architect, Butterfield was closely involved with the Camden Socety, his principal patron. Because of the Society's emphasis on ritual, Butterfield found himself designing not only the church buildings but their interior fittings as well. His close attention to the interior polychromatic effects of stained glass, murals, marquetry, gilding and a wide

35

range of other materials was extended to the exterior of his churches, with combinations of tile and red and black diaper work in colourful patterns. Butterfield's blend of structure, colour and different materials is well illustrated in All Saints' Church, Margaret Street, London (1849–59). An aggressive handling of hue and pattern combines with a wide range of textural variations in the multicoloured and alternating bands of brick, stone and wood on the exterior of his churches and the rich polychromy intrinsic to the marble, tiles, gilding and strongly contrasted tones in stained glass within. All Saints' was paid for entirely by Alexander James Beresford Hope, the most active lay member of the Camden Society.

SIR GEORGE GILBERT SCOTT A former follower of Pugin who briefly courted the Camden Society and then branched out to reach a broader church constituency was Sir George Gilbert Scott (1811–78), one of England's most prolific architects. Scott demonstrated his ability in both the classical and medieval modes. His first private commission was a house at Wappenham in the Georgian style for his father in the 1830s, but the bulk of his production is tied to the architecture of the Middle Ages, especially Gothic. Among his notable churches are St Giles, Camberwell (1842–5); Christ Church, Turnham Green, Middlesex (1841–3); and St John the Baptist, West Meon, Hampshire (1846).

Scott's eclectic Gothic facade for the Midland Hotel (design 1865) at St Pancras Station in London, with its great pile of lancet and trefoil arches accommodating a grand *porte-cochère* (gateway) and capped by giant spires set against the skyline, gave him one of his largest secular commissions. It was, however, his Gothic Revival style design for the Albert Memorial (1863–72) in Kensington Gardens, possibly inspired by another monument to the late Prince Albert in Manchester by Thomas Worthington, that earned him his knighthood from Queen Victoria.

Scott distinguished himself as a restoration architect, an aspect of his career that began with his commission to succeed Edward Blore in 1847 on the restoration of the famous medieval Ely Cathedral, now in the 1990s in the throes of a further restoration.

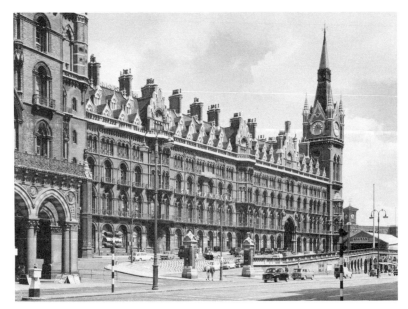

Midland Hotel, St
Pancras Station,
London. Sir George
Gilbert Scott,
1868–74.

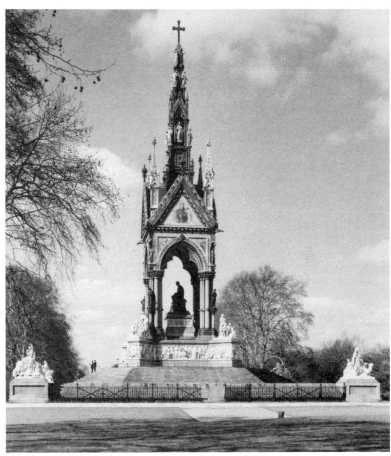

Albert Memorial,
London. Sir George
Gilbert Scott,
1863–72.

RUSKIN'S INFLUENCE: MORAL AND SOCIAL

In 1849, at the same time as All Saints' was commissioned, the writer and critic John Ruskin (1819–1900) published his famous *The Seven Lamps of Architecture*. This work may have influenced Butterfield's use of multicoloured and multitextured pattern borrowed from early Italian Gothic architecture. In his *Seven Lamps*, Ruskin laid down the enlightening principles which he believed architecture should embody under seven categories: sacrifice, truth, power, beauty, life, memory and obedience. The title's analogy to the seven gifts of the Holy Spirit may be extended to the seven symbolic lamps placed in the sanctuary during Pentecost. Very much a man of his times, Ruskin was concerned both with the ethical and the aesthetic and looked to models of the past for the solution of contemporary social, moral and political problems. Although he respected Greek art, he felt Gothic to be more appropriate for his age; besides, for him to accept pagan gods meant to deny Christ. He therefore rejected classical motifs and, like Pugin, looked to the Middle Ages, the Age of Faith, for inspiration and patterns. Ruskin saw there the appropriate model for moral and social reform. Pugin was inspired by its devotional and liturgical riches as well as a patriotic affection for English building of the thirteenth and fourteenth centuries.

While Ruskin's *Seven Lamps* recalls Pugin's *True Principles* in its evangelical tone as well as its insistence on authenticity of methods and materials, his *Stones of Venice* (1851–3) expressed his conviction that work itself was hallowed. In his famous chapter 'On the Nature of Gothic', he argued that 'art is the expression of man's pleasure in labour', as William Morris paraphrased it. With that chapter Ruskin believed that he had written the creed for a new school of thought about industry which was to exert a profound influence on William Morris and later the Arts and Crafts Movement.

As Pugin had shown a 'right' and 'wrong' way to practise architecture, Ruskin was just as dogmatic in asserting the propriety of individual historic styles and the 'right' way to appreciate architecture. Ruskin's influence extended beyond England to mainland Europe and to America, where his books commanded a wide readership to the end of the century. He influenced not only

popular taste, the direction of the Arts and Crafts Movement, and the practice of individual architects, but contemporary literature as well.

For example, Marcel Proust, whose psychological insight and style have been of incalculable influence on the novel, was awakened to Botticelli's women through Ruskin. Proust's pilgrimage to Amiens, as well as his tours through Normandy and Brittany in search of the medieval churches which so pervaded the mood and settings of his writings, were inspired largely by his work on translating Ruskin into French.

VIOLLET-LE-DUC: THE GREAT RESTORER

Along with Pugin and Ruskin, the third major figure in nineteenth-century Gothicism is Eugène-Emmanuel Viollet-le-Duc, whose theories exerted an international influence that paralleled Ruskin's and whose restorations have changed our contemporary view of whole towns. From a wealthy family, he shunned the Ecole des Beaux-Arts and earned his education and experience through his own initiative and personal connections. He studied buildings in Italy in the mid-1830s, and was helped by his contact with Prosper Mérimée. Mérimée wrote the novels *Colomba* and *Carmen* (the basis for Georges Bizet's opera), and was Inspector in the Commission des Monuments Historiques, the principal force in preserving medieval antiquities in France. Viollet-le-Duc became the major restorer of medieval churches, castles and other medieval buildings in France, including Notre-Dame, the Sainte-Chapelle and Saint-Denis in Paris, and the great church at Vézelay in Burgundy. Although he was an architect and France's leading restorer, his greatest influence was exerted through his writings. The *Dictionnaire raisonné de l'architecture française* and *Entretiens* set forth Viollet-le-Duc's ideas of how the skeletal construction of Gothic buildings resulted from practical solutions to structural problems. Both were very widely read in Europe.

Viollet-le-Duc saw the Gothic style as defined by its structural innovations; these were based essentially, he maintained, on the rib and its functions. The style's main characteristic was the perfect

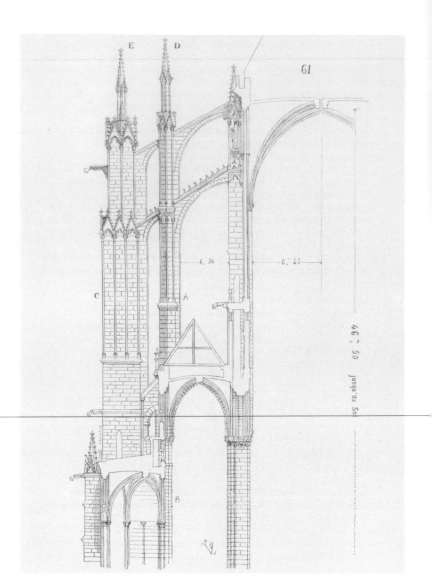

A page from
Dictionnaire Raisonné de l'Architecture Française by Eugène-Emmanuel Viollet-le-Duc, 1854–68.

equipoise of its skeletal components; this was produced by the precisely executed interdependence of all parts. The skeleton, for Viollet-le-Duc, was made up of the ribs (defining vaults) and the piers and buttresses supported by the foundations. The walls and webbing were infilling, to keep bad weather out and warmth or coolness in; they were not essential to the skeleton. In the perfect structure, according to Viollet-le-Duc's theory, not even one stone of the skeleton could be removed without destroying the building. This equilibration, as it was called, is what gave Gothic architecture its dynamic quality and made it like a living organism. Viollet-le-Duc's theory had many adherents well into the twentieth century.

When the damage of World War I bombings, however, laid bare the architectural anatomy of some of the great Gothic monuments whose ribs had been blown away but whose webbing continued to stand, the new evidence demonstrated that the essence of the Gothic style was defined by all the parts, including the walls and webbing.

Viollet-le-Duc observed a parallel between the masonry skeleton of the Gothic builders and the cast-iron skeletons of his own day, and his experiments with metal structures and tie-bars in his restoration work anticipated the space frames of today.

3 Architecture and technology

The specialised knowledge required by technical advances in metal construction in the nineteenth century encouraged the collaboration of architects, founders and engineers. At the same time, the introduction of mass production, brought about largely by the development of prefabrication methods (standardised interchangeable parts made in the factory but assembled on the site) and the advantages of regular wages for factory workers, made it possible to build serviceable structures without the direct participation of a trained architect. The architect Thomas Farnolls Pritchard and ironmaster Abraham Darby III erected (1779) the first iron bridge in the world, over the Severn Gorge in Shropshire. The millowner and engineer William Strutt, on the other hand, worked without a trained architect in designing and building a calico mill at Derby and a wool mill at Belper in 1792 involving a new use of metal supports and fire resistant materials and methods.

THOMAS TELFORD One of Britain's leading engineers, Telford (1757–1834) built mostly bridges, canals and aqueducts, and demonstrated a sophisticated command of architectural principles. Even though he was not a trained architect, Telford had worked for Sir William Chambers and throughout his career built toll-houses and churches in a classical style that could compare favourably with the designs of contemporary architects. St Katherine's Docks in London reflect the sturdiness of his style and an inventive adaptation of antique and medieval forms to contemporary industrial use. A brick mass of five storeys unified by relieved arches is supported by massive Tuscan columns that originally defined the large open dock area. It is interesting that since the closing down of many London docks (due to the use of containers), St Katherine's Docks have been put to totally new uses – some of which could be thought to have medieval associations; the place is a mixture of

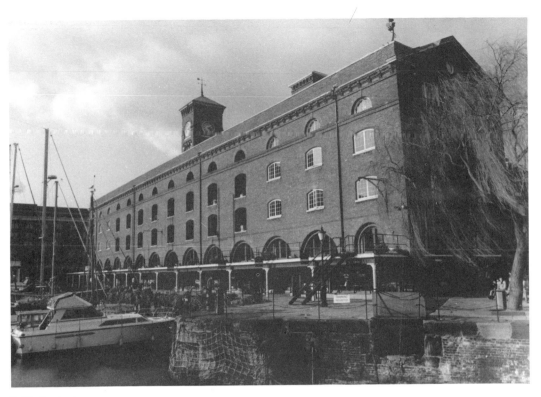

St Katherine's
Docks, London.
Thomas Telford,
1827.

artists' studios, craftsmen's workshops, dwellings and moorings for boats.

Although Telford built mostly in masonry and brick his achievements in iron were prodigious, and in some of his most innovative bridges he combined modern technology with forms of the past in true picturesque fashion. For example, the great towers to support the roadbed of the bridge at Conway Castle in north Wales sensitively copy the medieval silhouette, crenellations and rustication of the castle nearby that often attracted painters of the period. Here and in his earlier bridge over the Menai Strait between the mainland of northwest Wales and the Isle of Anglesey he suspended the roadbeds from chains, a new principle in metal bridge construction. James Finlay in the United States had patented a suspension system in 1808, which it is suggested that Telford probably knew.

ISAMBARD KINGDOM BRUNEL One of the Victorian era's great engineers, Brunel (1806–59) drew from Telford's Menai Bridge some lessons in suspending a roadway with his own suspension bridge spanning the Avon Gorge at Clifton in Bristol

43

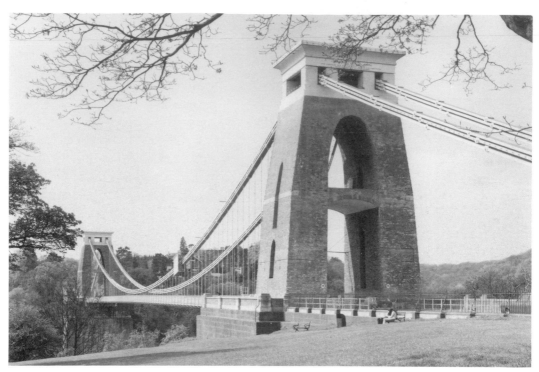

Clifton Suspension
Bridge, Avon
Gorge, Bristol.
Isambard Kingdom
Brunel, 1831–64.

(designed 1831, completed 1864). Attracted to the pylon temples of
ancient Egypt, Brunel's design featured colossal pylons with Egyptian decoration (most of which disappeared from the design before
construction) from which to suspend the roadway.

BROOKLYN BRIDGE: FIRST STEEL SUSPENSION BRIDGE

Even though the golden age of canals in Britain and North
America of the eighteenth and early nineteenth centuries was
eclipsed by rail transport at mid-century, bridge building
burgeoned afresh to fulfil the needs of new railways, and technology became increasingly more sophisticated. John A. Roebling,
his son Colonel Washington A. Roebling and Washington's wife
Emily Roebling built the first steel suspension bridge, the Brooklyn
Bridge, between 1869 and 1883. It was also the longest bridge in
the world – 486 metres. The bridge spanned New York's East
River and united the boroughs of Brooklyn and Manhattan. Techniques and devices were invented to weave wire cable into a
supporting web of steel on a mammoth scale that attracted worldwide interest and inspired artists then and since. John Roebling
conceived the great granite towers in the Gothic Revival style,
almost 90 metres high (48 metres above the roadway), as landmarks

44

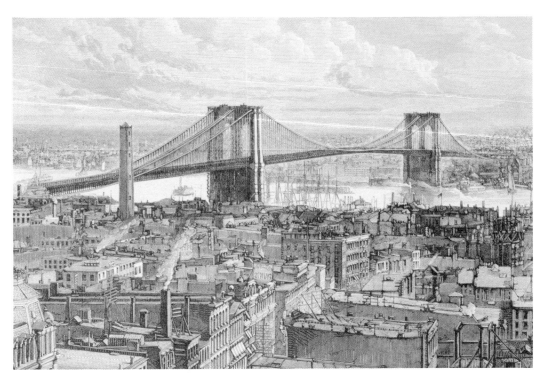

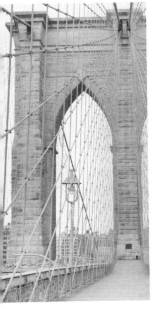

Brooklyn Bridge, New York. John A. Roebling, Washington A. Roebling and Emily Roebling, 1869–83.

to the two boroughs and deserving the status of national monuments. Tragedy, however, prevented his ever seeing them; he died of lockjaw as the result of an accident on the site just as construction started. His son completed the bridge even though his own health was permanently impaired by the 'bends' (caisson disease) which he contracted after long hours in the gigantic caissons sunk beneath the surface of the East River during installation of the foundations for the towers. (A caisson is a giant wooden box, inverted and filled with compressed air prohibiting the entry of water, which rested on the riverbed allowing workers inside to excavate for the foundations of the towers. Caissons were invented in Europe but the Brooklyn Bridge's caissons were the largest that had ever been constructed: the caisson for the Brooklyn side weighed 3,000 tonnes and was 51 metres by 31 metres.)

The Brooklyn Bridge has become a cultural symbol and a special inspiration to poets, painters and photographers, highlighted by the centenary celebration in 1983, in which the descendants of the Roeblings participated. In uniting Brooklyn and Manhattan, the Roeblings linked Long Island with the mainland and thereby supplied the final link between East and West that historians have related to Columbus' quest for a passage to India, an idea that is as

45

old as America. Roebling's two monolithic towers have become symbols of this notion of the threshold to America and have inspired artists and writers to paint the bridge and to write about it.

THE ARCHITECTURE OF THE INDUSTRIAL REVOLUTION

THE MACHINE IN THE GARDEN The industrial building that characterised the nineteenth century had its roots in Britain in the early days of the Industrial Revolution in the eighteenth century. Two developments in particular produced buildings that changed the look of the landscape: the development of blast furnaces for the production of cast iron (and the use of cast iron in buildings) and the invention of steam power.

Coalbrookdale in Shropshire, by the Severn Gorge, was the site of both of these developments, and is a place where many of the buildings characteristic of these developments can still be seen in a whole museum complex illustrating early industrial development. The foundries for smelting iron were built of brick with chimneys and square-topped blast furnaces. The easy availability of machine-produced cast iron influenced the design of buildings – both exteriors and interiors. Where wood had dominated, cast iron began to take over, in civil engineering for bridges and aqueducts (as seen in the work of Telford and Brunel), and also in the construction of factories, reducing the chances of fire. Even lintels and windowsills started to be constructed of iron. Ornamental railings, gates and spiral staircases were produced in quantity using the new technology.

Cast iron was used for the first time instead of masonry to construct a bridge over the Severn Gorge, giving the name of Ironbridge to the town that sprang up by it. It was the first to be built with a single span (250 metres), made up of five separate iron ribs, all constructed without the use of a single screw, nail or rivet. It has lasted for over two centuries, only needing some repairs to its foundations in the 1970s. It was so innovative that no one dared repeat the experiment for ten years, and it was not until the first quarter of the nineteenth century that cast-iron technology for bridge-building was exploited.

Decorative detail on the world's first cast-iron bridge at Ironbridge, Shropshire. Designed by Abraham Darby III and J. Wilkinson, 1779.

Structural advances provided the technology for bridge builders to span great spaces as in the Garabit Viaduct (1880–4) by Gustave Eiffel. Other bridge builders, using stone as well as cast iron, picked up new architectural features. The Wadesmill bridge (1825) in Hertfordshire rests on a pair of low arches supported by a row of Tuscan columns, and an iron bridge (*c.* 1840) at Gadebridge Park, Hempstead, features a low broad arch and openwork. Both bridges are sensitively adapted to their surroundings. They span small rivers whose calm surfaces reflect the medieval forms of the Wadesmill bridge and the lace-like openwork of the Gadesbridge Park bridge.

Towns that had not changed much since the seventeenth century were suddenly pitched into the Industrial Age by the construction of mills and factories, their tall chimneys dominating the skyline, their workers' terraced houses covering previously open spaces. Proximity to plentiful water supplies, to coalfields for fuel, to ironstone rock for iron ore, to canal and rail transport, to ports for import of raw materials and export of finished goods: these all influenced the location of the new industrial buildings. Textile mills, many of them impressive constructions with large windows, were built in previously undeveloped valleys of Lancashire and Yorkshire; massively built square tobacco warehouses gave a new character to such cities as Bristol. The previously exclusively rural and pastoral nature of such counties as Hertfordshire and Suffolk was changed by the new maltings, with their characteristic wide chimneys, built for the brewing industry; and beautifully functional pumping stations, with elegant chimneys, were built to drain previously uncultivated land, using the new steam technology.

Industrial architecture drew on contemporary design as well as on historical styles. The Simpson Brewery in Baldock (demolished 1968), for example, was a three-and-a-half-storey Georgian structure of brick and stone with a steeply pitched slate roof topped by a cupola and weathervane. And the Ashwell brewery, also in East Anglia, combines Georgian symmetry with Gothic arches and lancet-like windows.

Many of these buildings have in recent years become redundant, with changed economic conditions (the import of cheaper textiles from the Far East, for example). Although much has been

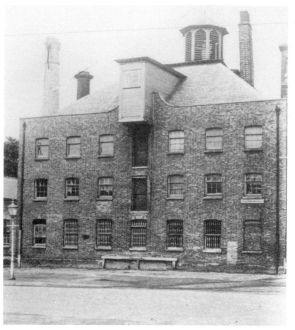

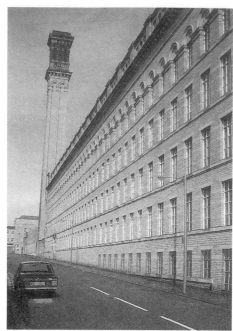

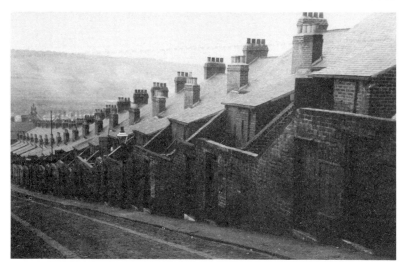

Building for
industry (*from top
left*): Simpson's
Brewery, Baldock;
Manningham Mills,
Bradford; workers'
housing, Newcastle
upon Tyne.

destroyed, a good number of these handsome and solid buildings
have been put to new uses: mills divided up into units to house
various forms of light industry; warehouses converted into apart-
ments; maltings turned into residential quarters or offices, or –
most famously at Snape in Suffolk for the Aldeburgh Music
Festival – into cultural centres or concert halls.

The development of rail transport was hailed as a great and
innovative step forward in transportation by many, while others

48

objected to its intrusion in previously untouched pastoral and wild landscapes. There was no doubt that the construction of the lines themselves, the cuttings and viaducts necessary for this, and the sight and sound of steam trains changed irrevocably the character of many stretches of British landscape. For some, such as the painter J. M. W. Turner, whose painting *Rain, Steam and Speed* was the epitome of the romantic response to this new form of transport, it produced an experience at once powerful and visually exciting.

METAL SKELETON CONSTRUCTION

Although the use of metal in building goes back to antiquity, its application to the development of skeletal construction in the eighteenth and nineteenth centuries was a response to the particular social, cultural and technological demands and developments of the Industrial Revolution. Iron was being used in architecture to support components of a superstructure by the 1770s (the galleries of St Anne's, Liverpool) and in 1792 William Strutt used vertical iron supports to carry timber beams in his mills at Derby and Belper. Soon after, mills in England were being built with iron skeleton construction throughout, which meant that the weight of the building was supported by the metal frame rather than by load-bearing walls. This was a principle that had profound implications for the architecture of the nineteenth century and that would find its mature expression in the skyscraper, the most revolutionary architectural achievement since the Gothic cathedral.

Prefabrication made iron construction economical and fast. The components of a building were produced in the foundry in quantities and then shipped to a specified site for assembly. The complexity of some structures required their assembly first at the point of manufacture where each piece was numbered, to assure correct and rapid reassembly (by matching up the numbers). The structure was then disassembled, shipped in parts and reassembled at the construction site. From domestic dwellings to churches and palaces, from lighthouses to mills and warehouses, iron buildings were manufactured in England and shipped all over the world.

PORTABILITY AND PREFABRICATION

There was nothing new about portable buildings. The American colonists' simple but sturdy oak frame houses were highly portable. When families moved, they could easily dismantle and reassemble their dwellings. Governor John Winthrop, whose house was cut and framed in Charlestown, Massachusetts, in 1630, took it with him when he moved to Boston soon afterwards. Slightly more sophisticated wood structures were prefabricated in Britain and exported. Soon after its settlement in 1788, for example, Australia imported from Britain houses made of wood, which provided better protection than the tents and primitive shelters set up by the first settlers. By the nineteenth century, portable houses could be erected with central heating, as illustrated in John Claudius Loudon's influential *An Encyclopedia of Cottage, Farm and Villa Architecture* (1833). A flue could carry heat from the cast-iron stove to each room in the house. At this same time, builders in New England were developing similar devices with the trusty Franklin Stove (named after Benjamin Franklin, who invented it) as the heat source. Prefabricated houses were especially popular and suited to their purpose during the gold rushes in California (1849) and Australia (1851).

'IRON-FRONTS' FOR COMMERCIAL USE The false fronts for commercial buildings became popular during the California gold rush. A flat-top store front applied to a gable-roofed structure offered a larger and more visible surface to the public and more space for the store's name and the merchant's advertising. A row of these squared false fronts facing the main street gave the street the look of a big city. While only rare fragments of the false fronts survive (Main Street, Rawhide, Nevada), they live on today in the Hollywood 'western', raised to the level of an art form, by such film directors as John Ford. New York foundries mass-produced hundreds of the Venetian-style 'iron-fronts' and many were shipped west on waggon trains to the 'wild west' towns of the new frontier where they were assembled piece by piece. Good examples are still to be found in Australia, particularly in Fremantle.

Foundries in Glasgow were also pioneers in manufacturing

'iron-fronts' in Europe for use there and for export. Gardner's furniture warehouse (now Martin and Frost, a furniture shop) on Jamaica Street in Glasgow (1855–6), designed in the Venetian Palazzo style by John Baird I, is a remarkably well-preserved example.

CAST-IRON HOUSES AND 'IRON POTS'

By the time of the gold rushes, cast-iron prefabrication was beginning to replace wood. The small prefabricated cast-iron house, called the 'cottage for the million', was especially popular in Australia. It consisted of two rooms, approximately 5 m × 3.5 m each. There were larger variations, too. One could order one of four rooms, for example, with entrance hall, closets, detached kitchen, veranda and venetian blinds. The prefabricated iron cottage of 1853 in Patterson Place, South Melbourne, is a representative example that still stands. Some of Australia's 'Iron Pot' churches, schools and theatres, as they were called, are still standing, although not always on their original sites, and they are testimonies to the endurance and portability of prefabricated cast-iron construction.

Early cast-iron prefabricated buildings had their drawbacks. Even though inexpensive to purchase, they were costly to erect, and they lacked insulation. At first, assemblage could be as much as seven times the cost of the building; still cheaper, however, than traditional construction. The scorching sun made the interiors hot and the early structures were criticised as being ugly.

As the industry grew, however, insulation was developed, cost of assemblage was reduced, and more attention was paid to style and decoration. In Australia, Corio Villa of Eastern Beach, Geelong, Victoria, 1856, manufactured in Glasgow, is a superb example in rare condition. Lace-like roof barges are accented by bold pendules, which cast ever-moving shadows over the pin-wheel roses that animate the recessed gables. Open relief work above the porches repeats the foliated filigree around the arched openings below.

As populations grew and society's needs changed and became

more varied and sophisticated, the rigid nature of prefabricated construction gave way to more flexible frame construction that combined both wood and metal technology and so became more adaptable to new demands. It was inspired by the so-called 'balloon frame' construction developed in Chicago in the 1830s. This method of construction was taken to Australia by Americans who migrated from the gold fields of California to the gold fields of Australia.

CAST-IRON ORNAMENT

While Australia's demand for cast-iron buildings declined as the country became settled, her demand for cast-iron decoration increased. To this day, Australia remains the largest repository of ornamental ironwork in the world, not only a testament to the country's art, craft and production, but a tribute to the desire to preserve its own heritage and art.

Because smelting began in Australia in 1848, but did not get fully underway until the 1870s, the country's cast-iron ornament is a blend of imported and locally manufactured production, which reflects a variety of styles, motifs and workmanship. The lion's head in the keystones of the prefabricated Corio house of 1856, for example, are from Britain and identified with the Crown. A wide variety of original designs are based upon indigenous flora and fauna, and they are executed in both expressive as well as airy lace-like patterns that are uniquely Australian. Many designs, for example, feature images of the kangaroo, kookaburra, emu and cassowary. The richest and most unusual patterns, however, are orchestrations of Australian fern, inspired by the country's numerous fern gullies, the nineteenth-century practice of growing ferns indoors, and the Victorian pastime of fern hunting. It is noteworthy that Australian coins also carry these indigenous motifs.

The Indian veranda was introduced into Australian architecture early on by military architects who had served in the East. Its execution in cast iron and its combination with the second-storey balcony afforded a kind of indoor–outdoor living form, especially suited to the country's climate. Moreover, this combination presen-

Cast-iron ornament, Richmond Arms Hotel, Richmond, Tasmania.

ted the nineteenth-century cast iron designer with a unique challenge: how to provide shade from the sun without obstructing the refreshing evening breezes. The cast-iron mantles of lace that the Australian designers produced to meet this challenge are a *tour de force* of practicality and beauty.

In the United States, excellent examples of ironwork are also to be found in the verandas and balconies of New Orleans, Louisiana, in both the French Quarter and the Garden District. Moreover, New Orleans has a rich collection of cemetery art and decoration in cast iron. Above-ground burial in the nineteenth century, necessary because of the area's high water-table, attracted a wide variety of cast-iron decorative, symbolic and narrative ornament.

As the Industrial Revolution progressed, the use of cast iron increased and spread throughout the world. Decorative cast iron began to take its place beside the older wrought-iron decorations of European cities and spread throughout the New World as well.

Cast-iron store at 478–482 Broadway, New York. Richard Morris Hunt, 1873–4.

CAST-IRON CONSTRUCTION IN THE UNITED STATES

The use of cast iron in buildings in the United States dates from early in the nineteenth century primarily in Pennsylvania, South Carolina, Massachusetts, New Jersey and New York. The world's largest collection of nineteenth-century cast-iron buildings is found in New York City, concentrated in Manhattan below Twenty-Third Street and in the area called SoHo. The name of New York's SoHo is an acronym for South of Houston Street, unlike the name of London's Soho district, which was taken from a hunting call so named because the area had been a favourite hunting site. New York's SoHo is made up mostly of warehouses, dating from after the American Civil War (1861–5). Produced by

some of the country's leading architects, these buildings reflect highly sophisticated designs, detailing and planning. In addition to cast iron, materials include brick, stone and terracotta in varying proportions and combinations. Many of them have now been converted into offices.

Iron frame construction and prefabricated standardised units, established by Daniel Badger and James Bogardus in their cast-iron facades and structural systems developed in New York in the 1840s and 1850s, were to have international influence on cast-iron construction and prefigure the skyscraper technology of the late nineteenth century.

Cast iron was an appealing building material because it was both fire-resistant and inexpensive. Even though cast iron would buckle and sometimes melt under intense heat, if the overall structure of the building was sound, cast iron withstood fires as well as traditional building materials.

Because cast-iron buildings were prefabricated of standardised units, which were bolted together, each piece could be replaced quickly and economically. Moreover, a coat of paint on a cast-iron building solved the problem of dirt and grime quickly and economically. It took longer to clean stone surfaces, and it was costlier to carve stone replacements. Cast-iron components were lighter than stone and took up less space, allowing more usable floor area. Furthermore, the more slender columns and piers at the ground level allowed more display space for emporiums and shops.

Because stone was a more prestigious material, however, cast-iron buildings grew more and more to look like stone ones. Decoration, for example, was cast to look like stone ornament. Renaissance, Baroque and classical motifs were the most popular. The addition of marble dust or sand to the paint of a cast-iron facade gave the surface not only the colour of granite or marble but also the texture of stone. Even today, it is sometimes hard to tell the difference between a stone column and a cast-iron one. That is why aficionados may be seen in SoHo on a Sunday afternoon outing applying a magnet to a column to determine if it is truly stone or cast iron painted to look like stone.

Among the most impressive and popular building types in cast iron was the emporium or large shop. Built to look like a Renais-

Laing Stores, New York. James Bogardus, 1849. This replication in steel erected in the South Street Seaport Restoration is faithful to the original facade and provides a record of warehouse construction in cast iron in the 1840s and 1850s.

sance palace, it featured costly imported goods: crystal, silver, silks, and the like. One of the last of the great cast-iron emporiums in this so-called 'Palazzo' style to escape the wrecker's ball is the E. V. Haughwout Building in New York City. Designed by architect J. P. Gaynor, its cast-iron facade was cast by Daniel Badger's Iron Works in 1857. Its design is based upon the Renaissance Ca d'Oro on the Grand Canal in Venice. The building is architecturally and historically significant not only for its cast-iron facade but also because it houses the first commercial passenger elevator made practical by the safety device of its inventor, Elisha Otis.

The earliest cast-iron buildings in New York were warehouses, and they had little decoration. Elegant Corinthian capitals, delicate rosettes, classical moulding and floriated friezes came later. As a result, the metal skeleton or frame of the building was revealed on the building's exterior. Hence, the simple grid form of the entire facade revealed the design of the internal skeleton of the building. This idea of the facade revealing that which lies behind it was to become a ruling architectural principle of the Chicago School in

56

the late nineteenth century and of the International style of the early twentieth century.

There are none of New York's early cast-iron warehouses left. However, in the South Street Seaport Restoration of nineteenth-century counting houses, row houses, shops, a fish market and a pier, one of the earliest warehouses has been faithfully replicated in steel, a tangible record of early cast-iron construction.

GUSTAVE EIFFEL: MASTER BUILDER OF FRANCE Experiments in iron construction during the first part of the century in England, France and the United States reached a triumphant climax in France's symbol of her own industrialisation – the Eiffel Tower. This was commissioned for the Paris Exhibition of 1889. It was also the tallest structure in the world (300 metres high), taller than its contemporary skyscrapers in the United States until the erection of the Chrysler Building in New York, William van Alen's Art Deco tower (320 metres high), in 1930.

Gustave Eiffel's Tower, in the heart of Paris, dominates the cityscape to this day but its fame has tended to eclipse its creator's other great achievements. Like many nineteenth-century builders, Eiffel was not an architect but an engineer although he took his degree in chemistry. He is celebrated for such works as the Bon Marché Department Store, Paris, his great bridges such as the Pont du Garabit and one of the most remarkable collaborations of an architect, engineer and sculptor in the creation of a national symbol, the Statue of Liberty in New York. Richard Morris Hunt, the first American architect to study at the Ecole des Beaux-Arts, designed the base; Frédéric Auguste Bartholdi, the Neoclassical sculptor, created the statue and Eiffel invented the internal metal skeleton to support the statue. The enormous size, irregular shape and unwieldy medium (thin copper sheets the thickness of a US penny) of Bartholdi's 46-metre-high figure of Liberty posed structural problems that were resolved by Eiffel's unique system of strapwork fixing the thin copper sheets of the statue's skin to a flexible metal skeleton anchored to a central core. Eiffel's early experiences made him singularly, perhaps uniquely, suited to create the armature for the Statue of Liberty. With the establishment of the railway in France, and the many bridges it required,

The Eiffel Tower, Paris. Gustave Eiffel, 1887–9.

Eiffel, then an ironworker, began working in railway and bridge construction. In building railway bridges, he learned how to make metal skeletons that would withstand expansion and contraction under great temperature changes, that would absorb the pounding of railroad traffic over them, that would resist wind and weather, and how to build those skeletons high and wide to carry trains over the deep and broad valleys and rivers of the hill country.

THE GLASS CAGE

Combining glass with the metal skeleton, called ferrovitreous construction, was pioneered as early as the 1770s in England and France. It reached a supreme point of sophistication and elegance in England in the building that housed the Exhibition of the Industry of All Nations, the first real world fair, truly international in its participants and universal in its exhibits. The Great Exhibition, as it was called, was launched under the patronage of Queen Victoria's husband, Prince Albert, by the Society of Arts, which had been founded in 1754 to encourage cooperation among the arts, manufacturing and commerce. The Prince saw the potential benefits of the exhibition and his steady hand and persevering spirit were largely responsible for the idea of an international exhibition becoming a reality. The opening on 1 May 1851 appropriately bore his stamp in the performance of the *Melody for the Violin*, which he composed for the event.

THE CRYSTAL PALACE The first of the great international and universal fairs, the Great Exhibition, had far-reaching effects on the technological, scientific and cultural life of the nineteenth century, just as the building that housed its over 100,000 individual exhibits had a profound influence on the course of architecture. As the leading industrial force in the world, Great Britain understood the value of increased international trade, and to that end provided 'an arena for the exhibition of the industrial triumphs of the whole world'. From its opening on 1 May to its closing on 18 October 1851, there were six million visitors.

Exclusive and picturesque, Hyde Park was chosen as the site for the exhibition. A great hall, appropriate to the event, would be constructed and then removed to another location at the end of the exhibition so as not to alter permanently the fashionable park. However, there were dissenters. Some were against the exhibition altogether; they feared that the expansion of international trade, encouraged by such activities, was a threat to British industry. Others objected to having it in Hyde Park, fearing that irreparable damage might be caused to the area from the construction work and heavy traffic that the exhibition would be sure to generate.

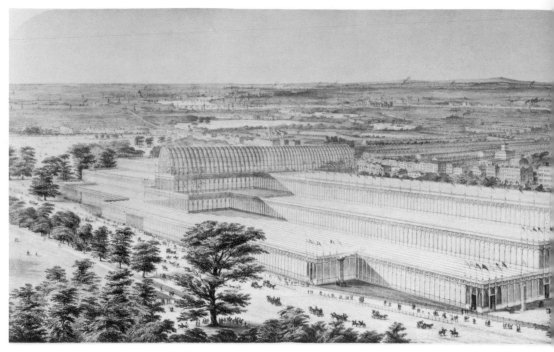

The Crystal Palace, London (almost totally destroyed by fire in 1936; finally demolished by bombs in 1940). Joseph Paxton, 1850–1.

Nonetheless, the Prince Consort, Sir Henry Cole and others of influence succeeded in shepherding the project to completion.

A competition for that 'arena' attracted 233 entrants from England and abroad who submitted over 240 plans. The Building Committee, composed of some of England's leading architects and engineers, convened to review the competing schemes, found none completely satisfactory and so drew up its own design.

At that point, June 1850, Joseph Paxton, not an architect but a self-educated horticulturist, entrepreneur and editor, who had distinguished himself as a skilful landscape gardener for the sixth Duke of Devonshire, requested permission to submit a plan in the competition. Paxton sought public support by publishing his design in the *Illustrated London News* of 6 July. This generated widespread and enthusiastic response. Further support from Prince Albert and other notables dispelled any remaining doubts the Committee had, and Paxton's plan was accepted.

Paxton had employed an ingenious system of ferrovitreous construction in building conservatories to house the Duke's exotic plants from all over the world. Having earlier devised a method of setting plates of glass into channels carved out of wood frames, Paxton adapted the principle to metal and glass in a ridge-and-furrow system for his greenhouses. Each unit of glass and metal

could be produced rapidly and cheaply. The entire structure was essentially composed of multiple standard units, which meant that assembly on site was easy and fast. Through the application of Paxton's system to the enormous hall for the exhibition, prefabrication was employed on a grander scale than ever before.

Construction began in July 1850, and was completed in February 1851, allowing enough time to install the exhibits for the opening in May. The unprecedented speed with which the building was erected made Paxton's cage of glass appear to materialise miraculously from nothing; the sheer magic of the apparition did much to dissipate the public opposition that still remained. The many commentaries on and illustrated views of Paxton's great glass cage used a vocabulary that reflected a conscious debt to Romanesque and Gothic buildings united to ideas of the picturesque and the sublime.

The imposing 'vestibule' of the main entrance (south side) was picturesquely situated opposite the Prince of Wales' Gate, one of the main openings to Hyde Park. With over eight hectares of floor space (about four times that of St Peter's in Rome, the Catalogue noted), its 'nave' alone was 22 metres wide, 20 metres high, and 563 metres long, flanked by 'side aisles' 7 metres wide carrying 'galleries' the full length of the building and completely around the 'transept' arms. The building called to mind the ground plans of such hallowed pilgrimage churches of the Middle Ages as St-Sernin at Toulouse in the Languedoc region of France.

Paxton's transept was arched to avoid cutting down two giant elms. A fountain of crystal glass marked the point where nave and transept intersected like an enormous medieval church crossing in which the builder united the wonders of nature with the creation of man. Inspired by the grandeur of the event, to which Paxton's building contributed in no small measure, Queen Victoria was moved to write in her diary, after the first of her many visits to the exhibition, that it was 'a "Peace Festival", which united the industry of all nations of the earth'.

Architect Owen Jones, who had a major influence on the decorative arts of the period through his widely read publications, executed the interior decorations. Through his extensive use of primary colours, he brought the exposed structural components

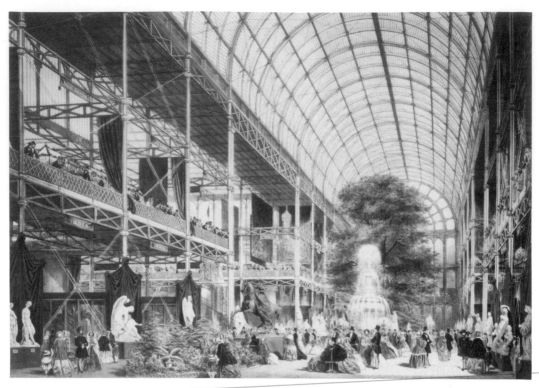

into harmony with the resplendence of Paxton's glass cage. Yellow columns accented with blue beneath red girders enhanced the long perspective of the nave and transept arms.

Little doubt was left in the mind of the bedazzled spectator that this was indeed a temple of commerce. The impact of the hall's palatial transparent splendour and its grand grid of metal and laminated wood with glass on an unprecedented scale did not escape the discerning sensibilities of Douglas Jerrold, of the humorous magazine, *Punch*, who called it 'The Crystal Palace', the name it kept.

The revenue from the Great Exhibition paid Paxton his fee of £5,000 and left enough to finance museum and educational programmes that to this day continue to promote the arts and sciences. When the exhibition closed, the Crystal Palace was dismantled and reassembled (and enlarged) at Sydenham Hill in 1852. There it served as a great pleasure palace, a recreation area, until 1936 when it was almost totally destroyed by fire. The surviving remnants were demolished by bombs in 1940.

Paxton's building inspired Crystal Palaces in many of the leading cities of the world. It occupies a pivotal postion in the progress and

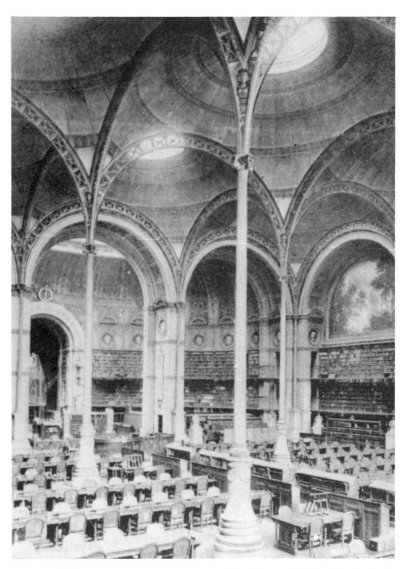

Reading Room,
Bibliothèque
Nationale, Paris.
Henri Labrouste,
1862–8.

history of ferrovitreous construction. The Crystal Palace looks back to the technological advances of the previous century in metal and glass skeletal construction and mass production developed in building the mills, warehouses, bridges and churches in England, followed in France by further innovations in iron framing. It looks ahead to the geodesic domes designed by Buckminster Fuller and the light-metal construction of Jean Prouvé in our own day.

FERROVITREOUS DEVELOPMENTS Ferrovitreous construction became widespread throughout Europe and the United States especially in public buildings. It was particularly well used in the

fashionable galleries and arcades raised on masonry supports and covered by roofs of iron and glass such as Galleria Vittorio Emanuele by Giuseppe Mengoni in Milan; the Providence Arcade by Russell Warren in Providence, Rhode Island; and organisational headquarters such as the London Coal Exchange on Lower Thames Street with its glazed dome above a metal cage by J. B. Bunning; or Benjamin Woodward's University Museum in Oxford with its iron and glass roof in Gothic Revival style, under the direct influence of John Ruskin, who designed at least one of the windows. Metal construction earned unique prestige in Henri Labrouste's Reading Room of 1862–8 at the Bibliothèque Nationale in Paris.

RAILWAY STATIONS: MIRRORS OF THE TIME

Building in metal and glass played a major role in the development of a new architectural form in the nineteenth century – the railway station. Born during the 1830s of the changing pattern of transportation brought on by the Industrial Revolution, it reflected, like the bridges, the eclectic character of its times in combining masonry forms from antiquity with ferrovitreous forms of modern technology. While the earliest station at Crown Street in Liverpool of 1830 no longer stands, Brunel's Temple Meads station in Bristol (1839–40) is still intact, not only a monument to a building type but also a fitting memorial to Brunel: builder of the Great Western Railway, the Clifton Suspension Bridge and the SS Great Britain, the great iron ship towed back from the Falkland Islands where she had lain derelict for many years, restored in the 1980s and on view in Bristol today.

The station's debt also to the picturesque is exemplified by John Dobson in his Central Station at Newcastle upon Tyne, a design which won a Medal of Honour in Paris in 1855. An arch leitmotif is established in the vaulted passage of the projecting stone *porte-cochère* which is beneath a stately entablature supported by nine sets of paired columns. In adapting the depot to the curved tracks (dictated by the site) behind the classical masonry facade, Dobson erected three arched sheds (each 18 metres wide) whose glazed

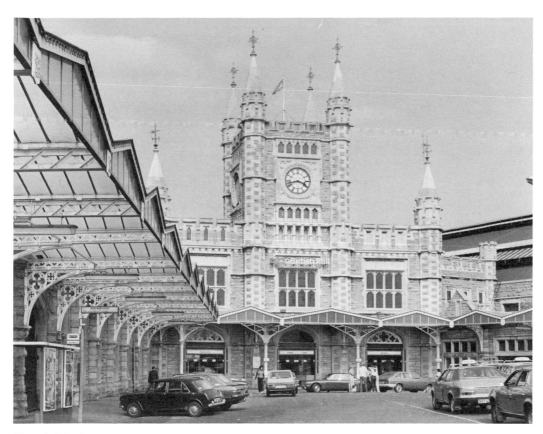

Temple Meads
Station, Bristol.
Isambard Kingdom
Brunel, 1839–40.

concentric vaults appeared to diminish in the distance when viewed from the usual vantage point parallel to the tracks. This was a new idea in the architecture of the train shed.

These new structures and their environments were to inspire contemporary artists, notably the Impressionists such as Claude Monet, whose interest in the changing properties of light and colour was stimulated by the visual effects of the sun streaming through sheets of glass and mixing with the locomotive's evanescent steam.

4 The Skyscraper

The metal skeleton and ferrovitreous design had their most revolutionary expression when they were united by the passenger elevator, invented by Elisha Otis in 1854, in the modern skyscraper. Although skyscrapers had their forerunners in the thirteenth-century towers of such places as San Gimignano in Italy, we now think of skyscrapers only as tall buildings of steel skeleton construction equipped with high-speed elevators.

Born of the desire of building owners to gain greater income by leasing more space where land was limited, or commercial districts were congested, the skyscraper originated in New York and Chicago between the 1870s and the 1890s. The greatest growth in its early development took place in Chicago following the famous fire of 1871 which decimated the city that had by then become America's mid-continental shipping centre. The new skyscraper design offered Chicago speed, efficiency and economy in rebuilding and, over the next two decades, produced virtually a new city of steel and stone.

THE ELEVATOR BUILDING

Although the first 'elevator buildings' were erected in New York, building codes impeded speedy development of the new building type there until in 1892 new legislation made greater provision for skeleton construction. George B. Post's Equitable Life Assurance Building, his Western Union Building, and Richard Morris Hunt's Tribune Building, were the earliest examples of what were known as 'elevator buildings', referring to their passenger elevators which made it possible to build to new heights (people would not walk up more than five flights) and make the upper storeys as desirable as the lower ones.

In the Western Union and Tribune buildings, Post and Hunt introduced innovative designs that shared a common organisational

66

principle. Above the basement level and below the roof the floors were unified structurally and visually by a similarity of formal treatment which made the building appear to be divided into a base, shaft and capital, like a classical column. This organisation remained a dominating principle of skyscraper design well into the twentieth century.

SKELETON CONSTRUCTION AND THE CURTAIN WALL

The metal skeleton soon replaced load-bearing masonry, making it possible to build on a site of almost any size without taking up much space for foundations and walls. Regulations governing the new skeleton or 'cage' construction replaced the laws of masonry building that taller buildings have thicker walls. Consequently, the thinner walls permitted by the new code allowed more usable floor space and more window area.

The first tall building in which skeleton construction was used throughout, and which therefore has been called the first modern skyscraper, was the Home Insurance Company Building in Chicago by William Le Baron Jenney, an engineer-architect from Massachusetts, who had studied in Paris and settled in Chicago. Jenney took the load off the masonry wall, the principle first employed in the English mills in the 1790s, and placed it on the skeleton frame of iron and Bessemer steel set within the wall. Jenney was also one of the first to use structural steel made from the industrial process invented by Sir Henry Bessemer of Sheffield, known internationally for its steel.

Soon after the Home Insurance Building, William Holabird and his partner Martin Roche, who had both worked in Jenney's office, introduced the concept of the 'curtain wall' to skyscraper design in their Tacoma Building. Its two principal facades, carried by the metal skeleton within, hung like great curtains of brick and terra-cotta keeping out the weather.

THE CHICAGO SCHOOL The skyscraper in Chicago of the 1880s began to reflect its skeletal construction externally in the grid pattern of vertical supports and horizotal beams that Bogardus had

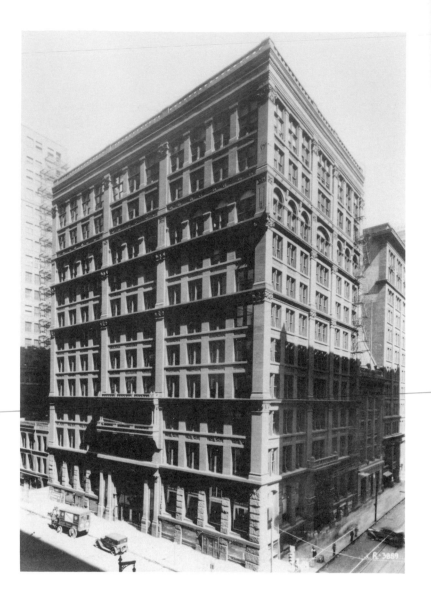

Home Insurance
Company Building,
Chicago. William
Le Baron Jenney,
1883–5.

pioneered in his cast-iron fronts in New York in the 1850s and that
had migrated westward later in the century; consequently, the
internal structure was seen to dictate the external form, a guiding
principle expressed later as 'form follows function'.

A predisposition towards skeletal construction and modern func-
tionalism in Chicago may be seen to have existed there already in
the 'balloon-frame' construction, an indigenous mode developed
there in the 1830s to satisfy the need for building rapidly and
economically when the city was being developed. This system
consists of light lumber frame construction in which studs (vertical

supports) and cross members are nailed together to form a grid-like wooden skeleton which harks back to the half-timber frame buildings of medieval times. Another source is the so-called 'Stick Style', a post-Civil War style which revealed its underlying wooden skeleton on the exterior walls.

There emerged in Chicago a common vocabulary of forms such as 'Chicago window', a wide central pane of glass flanked by narrower sashes, sometimes double hung (supported on either side by a counterweighted sash cord for easy raising and lowering). These identified the style of the building as belonging to what became known as the 'Chicago School'.

One of the foremost figures in the Chicago School was Louis Sullivan, who worked under Jenney and was Frank Lloyd Wright's master. He came from Boston, and studied architecture at the Massachusetts Institute of Technology and in Paris before joining the office of Dankmar Adler in Chicago in 1879 (the firm became Dankmar and Sullivan in 1881).

The design of Sullivan's Guaranty Building in Buffalo, New York, achieves a balance between form and function towards which the style had been moving over the preceding decade. The traditional tripartite organisation (base, shaft, capital) is conveyed in a delicate curtain of exquisitely detailed terracotta cladding that snugly contains the Guaranty's steel skeleton. At the base, the

Decorative relief work, Guaranty Building, Buffalo, New York. Louis Sullivan, 1894–5.

intercolumniation (distance between the columns) reflects the skeleton of the cage, in this case so spaced as to allow broad shop windows. This treatment of the basement level differentiates it from the 'shaft' above, which is composed of slender arched bays, allowing an abundance of windows that reveal the interior spatial organisation. The great corner piers that seem to bear the weight of the building rise to a dramatically projecting cornice at the attic level defined by lidded oculi (like eyelids) that appear to open and close as the light shifts. Although at times Sullivan criticised the use of decoration (as in *Kindergarten Chats*, his ideas serialised during 1901–2), the profusion of elegant and subtle relief work depicting organic forms that covers his buildings is characteristic of the contemporary Art Nouveau.

Sullivan designed the Transportation Building for the World's Columbian Exposition of 1893, which along with the Auditorium Building (Adler and Sullivan's first major building) showed his debt to Henry Hobson Richardson's Romanesque Revival style in his use of the arch and rustication on a colossal scale. Richardson's learned and imaginative use of medieval models had exerted a liberating influence on utilitarian architecture in America.

THE WOOLWORTH BUILDING: CATHEDRAL OF COM-MERCE A remarkable blend of east and west practices was to be seen in the buildings of Cass Gilbert, who came from Minnesota to New York, where he built the US Custom House. He stayed to become one of New York's leading architects. He was influenced by such great French buildings as Charles Garnier's Opéra of 1875 in Paris. The building that best demonstrates his own sensibilities as an architect and his contribution to uniting the functionalism of the Chicago School with the historicism of the eastern establishment is the Woolworth Building.

To provide a headquarters for his Five-and-Ten-Cent Stores, Frank W. Woolworth wanted a Gothic building with a tower and lots of windows (there are over 5,000) in order to allow the subdivision of interior spaces with ample natural light. Woolworth gave the commission to Cass Gilbert, whose successful use of Gothic decoration in his 90 West Street building in New York appealed to him.

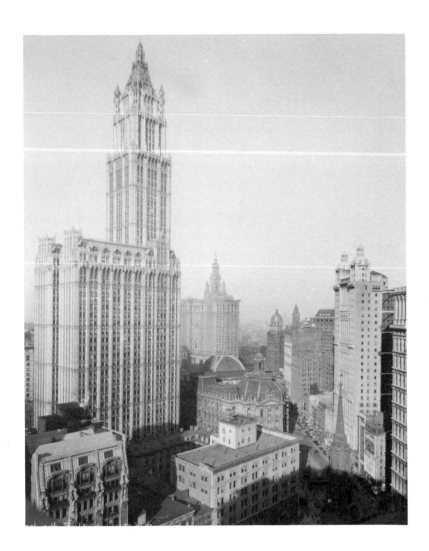

Woolworth Building, New York. Cass Gilbert, 1913.

Christened the 'Cathedral of Commerce' by a noted divine of the day, it was, until 1930, the tallest office building in the world (242 metres high). The Eiffel Tower was the only structure taller. It was formally opened at an elaborate ceremony by the President of the United States. Woodrow Wilson touched a switch in Washington, DC, which turned on all the lights of the building on Broadway in downtown New York and activated a device that broadcast a message across the country and to the Eiffel Tower. From there the message was transmitted to all the ships at sea that the Woolworth Building was open.

Gilbert wanted the exterior to express the internal steel structure while at the same time producing a 'picturesque' and Gothic effect. He chose the Flamboyant ('flame-like') Gothic style of the late

71

fifteenth and early sixteenth centuries and the medium of terracotta. Both the style and the medium allowed a wide range of possibilities in modelling and colour.

Gilbert decided on a matt cream glaze for the terracotta cladding accented with spandrels and detail in buff, blue, green, golden yellow and burnt sienna. The vertical lines of the facade are emphasised by diagonal projections, which picturesquely catch the light and cast shadows, while belt courses (horizontal bands) of coloured spandrels and tracery express the steel skeleton beneath.

To give the building the appearance of overall uniformity of tone, the matt cream glaze of the cladding and the colours of the spandrels are increased in density gradually from the bottom of the building to its top. This compensated for the increased intensity of natural light at the upper levels where there was less interference from surrounding structures. (Now, of course, tall buildings surround it.) Hence, while the tone of the terracotta at the third floor appeared to be of the same density as the tone of the terracotta at the upper floors, it was actually lighter. Similarly, the decorative relief was progressively bolder and more deeply undercut in the upper storeys to create the appearance of uniform light and shade.

In the tower above the twenty-seventh storey with its flying buttresses, pinnacles and projecting grotesques, the wealth of modelling as seen from below creates the illusion of delicate lacework culminating in a profusion of diaphonous forms which make the topmost part of the tower appear to merge with the atmosphere. The roof rises 38 metres; it is sheathed with ornamental copper in the late Gothic style and was originally covered in gold leaf. Gilbert designed the gilded apex and the carefully modulated colours of the terracotta to blend the tower with the subtle atmospheric nuances of blue and grey skies and to make it soar.

The union of functionalism and historicism in the Woolworth Building is expressed symbolically on the facade in the coiled salamanders carved beneath the two niches that flank the main entrance. The salamander, which the ancient world believed to be unharmed by fire, became the symbol, in alchemy, for the transmutation of baser metals into gold. In the Woolworth Building, the salamander stands for the transmutation of iron and clay into steel and terracotta, the two basic structural components of the building.

Both the salamander and the flame-like tracery of Flamboyant Gothic signify the means whereby the transmutation takes place. From flame and heat, ancient properties of the hearth, came the technologies of ceramics and metallurgy. From that same hearth, as Gottfried Semper believed, came architecture itself.

The skyscraper was born when the cost of real estate made the tall building appealing, and when the steel skeleton and the passenger elevator made it possible. In Chicago, the urgent need to rebuild the city's commercial community produced a box-like building that expressed its steel skeleton through its cladding. More dependent upon historical styles, the New York skyscraper was more often a shaped tower that reflected the building's internal skeleton, but clad in familiar decoration, usually classical or medieval.

These two sensibilities, the functional and the decorative, would continue to govern skyscraper design into the twentieth century with ever-changing results.

ART NOUVEAU

Among the forces that brought about the remarkable compression of the arts and technology toward the end of the nineteenth century into what became known as Art Nouveau were the prevailing notions of aestheticism and industrialisation.

As the load-bearing wall gave way more and more to skeletal construction in the course of the century, and as metal technology provided ever more sinuous and slender forms to enclose space, architecture, the decorative arts, and painting and sculpture became more intimately united than they had been since ancient times, when they were conceived of as one.

The hallmark of Art Nouveau was the sinuous line, and it was translated into every conceivable form and material. That translation is best epitomised in the German sculptor and designer Hermann Obrist's (1862–1927) *The Whiplash* of 1895, a silk embroidery on wool. In that work, Obrist attempted to give permanence to the laws he observed in nature. In his fountain of 1902 for Kempten in Bavaria, he extended his image to the third dimension.

The Whiplash.
Hermann Obrist,
1895.

Elvira Photographic
Studio, Munich.
August Endell,
1896–8.

August Endell (1872–1924), the other most notable German practitioner of Art Nouveau, expressed his ideas with greatest clarity in his renovation of the Elvira Photographic Studio in Munich (1896–8). He played wavy marine forms across the broad smooth expanse of the building's facade to unite its asymmetrically placed windows and main entrance. Executed in turquoise and red stucco relief, Endell's facade became one of Art Nouveau's most popular designs.

74

Book cover of
*Christopher Wren's
City Churches* by
Arthur Heygate
Mackmurdo, 1883.

The origins of the Art Nouveau line are to be found in plant forms in nature. The style that resulted from translating the sinuous forms of plants into architecture, painting, sculpture and the decorative arts emerged from the art of William Morris and the Arts and Crafts Movement. Other formative influences on the Art Nouveau style include the art of William Blake, that of the Pre-Raphaelites, Oriental and Celtic art, medieval book illumination and stained glass, and the paintings of James Whistler. Its name derives from the Maison de l'Art Nouveau, the name of the shop in Paris of the German art dealer Siegfried Bing, who specialised in contemporary art.

SOME IMPORTANT ART NOUVEAU DESIGNERS

MACKMURDO AND MACKINTOSH In Britain, the main practitioners of the style were Arthur Heygate Mackmurdo (1851–

75

1942) and Charles Rennie Mackintosh (1868–1928). Mackmurdo perpetuated the ideas of Ruskin and Morris through the Century Guild he founded in 1882 for architects, artists and designers and the *Hobby Horse*, an avant-garde periodical. In 1883, he published drawings of Christopher Wren's City churches which he illustrated in a sinuous, tendril-like style that had a formative influence on Art Nouveau in Britain and marked the beginning of a new style with international influence.

Mackintosh's masterpiece was his design of 1896 for the Glasgow School of Art, which combined the sinuous curves of Art Nouveau with crisp rectangular forms, synthesised the freely playing character of Art Nouveau ornament with functional considerations, and demonstrated a rare sense of spatial interpenetrations. His innovative conflation of the old and new is most dramatically expressed along the west wall where he took the traditional oriel window, compressed its glass into a modern pilaster, framed it in an iron grid, and opened up the wall in a design never contemplated before.

Mackintosh's tea rooms for Kate Cranston in Glasgow, begun in 1897, uniquely expressed the synthesis of his sympathy with the Scottish past and his daring innovation. The only survivor, the Willow Tea Rooms in Sauchiehall Street in Glasgow, was restored in 1981.

Mackintosh's influence was greater outside Scotland, but the 'Hatrack' building in St Vincent Street (1899–1902) in Glasgow by architects James Salmon and Son, reflects Mackintosh's interpretation of the Art Nouveau style in the blend of curve and grid of its narrow facade, only 7 metres wide, thus the nickname.

No other architect in Europe at that time embodied the diversity of Mackintosh, and his innovations made a deep impression on contemporary architecture outside the United Kingdom. Austrian architects, for example, knew his work from the new art magazine, *The Studio*, and saw his architecture and furniture designs exhibited at the Sezession gallery in 1900 in Vienna. Along with Joseph Maria Olbrich (1867–1908), who designed the Sezession in 1897–8, Mackintosh succeeded in combining sinuous forms within rectangular structures. That conflation of organic and geometric forms is fully expressed in Olbrich's last major building, the Tietz depart-

Glasgow School of
Art. Charles Rennie
Mackintosh,
1897–9.

ment store in Düsseldorf, which was to become very influential in
the twentieth century.

HORTA AND VAN DE VELDE IN BRUSSELS The first full
expression of Art Nouveau in architecture, according to many
historians, is Baron Victor Horta's (1861–1947) Hôtel Tassel in
the rue Paul-Emile Janson (1893) in Brussels. Its main staircase
with exposed iron supports and floral iron ornament twists and
turns like a growing plant, and writhes with curvilinear wall decora-
tions in a bold expression of Art Nouveau sinuosity.

Soon after 1895, Henry van de Velde (1863–1957), primarily a
painter and designer, designed his own house and furnishings at
Uccle near Brussels in the new style. The same year, he designed

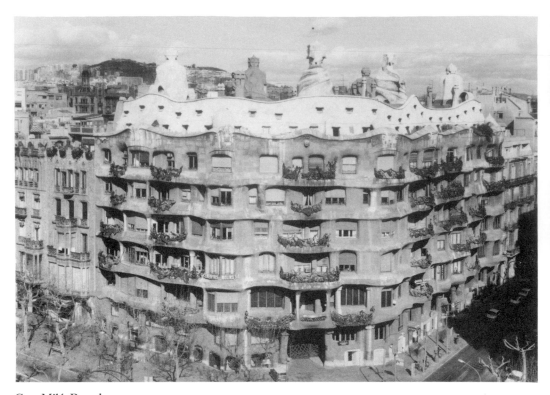

Casa Milá, Barcelona.
Antonio, Gaudí,
begun 1905.

the interiors for German art dealer, Siegfried Bing's newly established shop, Maison de l'Art Nouveau in Paris, the shop that gave the style its name.

GUIMARD IN PARIS The most daring and sophisticated practitioner of Art Nouveau in Paris was Hector Guimard (1867–1942), whose debt to Horta is evident. Guimard's block of flats in Paris, Castel Béranger (1894–8), is distinguished by its innovative interiors in metal, faience and glass bricks. His Métro stations in Paris (1899–1904) are simply triumphal lattices celebrating the passage from one space to another, daring for their time.

GAUDI IN BARCELONA The architect who pushed the decorative qualities of Art Nouveau to their limits was Antonio Gaudí (1852–1926) of Spain. His eclectic style combines Moorish and Gothic elements with primal forms of animal and sea life in his church, house and park designs. In all his Barcelona buildings, from his addition to the conventional neo-Gothic Familia Sagrada church, the town house for his longtime patron Count Güell (1885–9), the Parque Güell (1900, begun), to the luxury flats Casa

78

Battló and Casa Milá (both begun 1905), the facades undulate, and the rooms have no straight walls, no right angles. They are accented with sharp outcrops of broken tile and crockery and rock, and aggressively twisting wrought-iron balconies. Although Art Nouveau is seen as the first international reaction against historical revivals, Gaudí enfolds and blends historical forms and traditional materials into his buildings that express his unique vision of the world.

5 Domestic architecture

Three main types of domestic architecture were developed by the ancient Romans and these find their equivalents in nineteenth-century architecture: the *domus*, or town house; the *insula*, or multiple-storey apartment house or tenement block; and the *villa*, or detached house.

TENEMENTS

The largest and most diverse collection of high-quality nineteenth-century tenements that still exists is to be found in Glasgow, Scotland, the second city of the British Empire during the Victorian era.

Modern Glasgow is primarily an industrial city, founded originally on the eighteenth-century tobacco trade and nineteenth-century manufacturing. The architecture that housed the people and the places that made up and supported their textiles, ship building, steam locomotives, iron, coal and chemical industries form a unique heritage of commercial and industrial buildings, tenements and terraces.

Most middle-class people lived comfortably in tenement buildings, usually four storeys high. Each flat runs from three to eight spacious rooms with high ceilings and wide windows, more ample than the small terrace house in England in which their opposite numbers lived. The working classes in Glasgow also lived in tenements – but on a smaller scale, so provision for sleeping was made by concealed beds in a recess in the sitting room or kitchen.

These tenements reflect a wide array of architectural styles spanning a half-century. Sharing Cross Mansions, for example, designed in 1891 by Sir J. J. Burnet, one of Glasgow's leading Victorian architects, who studied at the Ecole des Beaux-Arts in Paris, was inspired by the Hôtel de Ville in Paris. Breadalbane Terrace on Hill Street of 1845 is an early tenement in the Italian

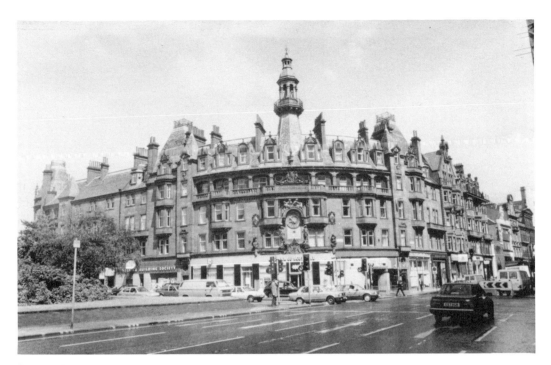

Sharing Cross
Mansions, Glasgow.
J. J. Burnet, 1891.

Renaissance Palazzo style. A feeling of Baroque grandeur still lingers in the use of Corinthian pilasters to unite the storeys of the range of tenements on Minerva Street and Argyle Street (1853).

THE DETACHED HOUSE

Although domestic dwellings in all countries have distinctive characters and are a matter for cultural investigation, the development of the detached house in England and in the United States in the nineteenth century is of unique architectural significance. It provides the basis for the twentieth-century house in which key aspects of domestic design reach maturity, and it therefore requires special attention.

ORIGINS IN THE YEOMAN'S COTTAGE The detached house has its origins in the yeoman's cottage, just as the terrace house has its origins in the medieval urban houses of the skilled artisan class.

The yeoman's cottage was a small rustic shelter, beginning as a one-room structure of rough-hewn timber frame (later came stone foundations) and in-fill of mud or plaster with a steeply pitched

81

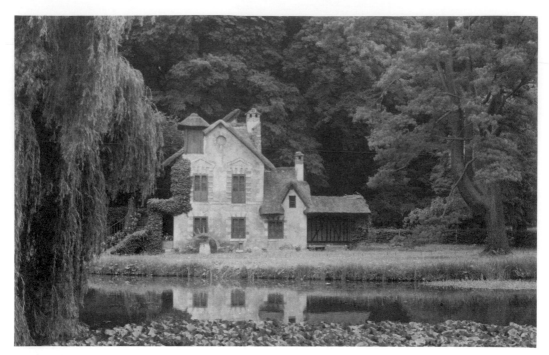

Hameau, Petit
Trianon, Versailles.
Richard Mique,
1783–6.

thatched roof. Wood was in plentiful supply from the many forests, and straw thatch effectively shed the rain. A large fireplace supplied warmth for living and fire for cooking. As families got larger, rooms were added and the cottage grew asymmetrically in plan and silhouette. More permanent walls of locally quarried stone supporting weatherboard gables often replaced wood-frame construction; roofs were often of slate, and wooden floors were added.

The yeoman's cottage was idealised in French, English and Netherlandish landscape and genre paintings from the seventeenth century onwards, and became the model for eighteenth-century 'follies'. Perhaps its most remarkable expression as a folly was architect Richard Mique's rustic design (1783–6) for Marie Antoinette at the Petit Trianon. Here, the architect built an actual hamlet of these cottages, which included a dairy and a mill where Marie Antoinette, with her companions, could play at being shepherdesses and dairymaids.

THE COTTAGE ORNÉ IN BRITAIN

During the nineteenth century the same cottage mode caught on in England, where architect John Nash designed an entire village

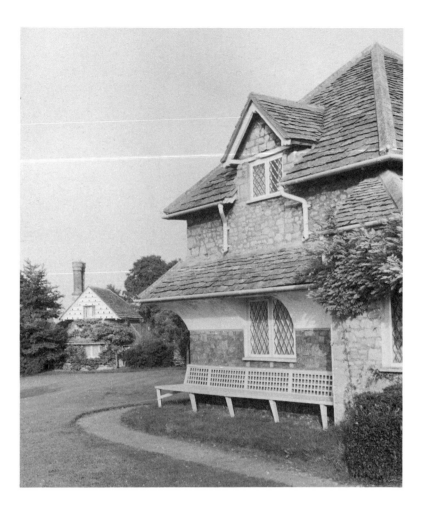

Blaise Hamlet, near
Bristol. John Nash,
1811.

outside Bristol called Blaise Hamlet in 1811. Whereas Mique's
creation was admittedly a 'folly', Nash's design was an innovation in
his effective use of the rustic cottage mode in developing pic-
turesque urban housing. Moreover, each cottage was different in
plan and execution offering individuality, thereby appealing to a
fashionable clientele. William Butterfield's vicarage at Coalpit
Heath, Gloucestershire, 1844–5, illustrates the continuing
popularity of the mode at mid-century. And Sir Edwin Lutyens'
Deanery Gardens of 1901 at Sonning, Berkshire, is evidence of the
style's adaptability to changing taste and its persistent appeal into
the early twentieth century. The mode was dubbed the 'Cottage
Orné', and its French name enhanced its distinction and appeal.

Innovations in the medieval cottage style were introduced in
1859–60 by architect Philip Webb in his so-called Red House
(because of its red brick exterior instead of the traditional field-

83

Red House,
Bexleyheath, Kent.
Philip Webb,
1859–60.

stone) in Kent for artist and founder of the Arts and Crafts
Movement, William Morris and his wife, Jane Burden. In the Red
House, Webb adapted the cottage mode to the contemporary needs
of an artist and his wife, whose living space was often filled with not
only friends but also artists and business associates. The need for
more ample and functional spaces, for example, produced a modi-
fied stair hall that was to have broad implications both in Europe
and in the United States. Hitherto, the primary function of the stair
hall was to move traffic up and down stairs. Webb's stair hall is
larger to accommodate additional furniture and storage space at
ground floor level. It also provides central and easy access to the
other rooms on the ground floor and provides more open spaces on
the floor above.

In Benfleet Hall, Cobham (1860), built for the painter Spencer

84

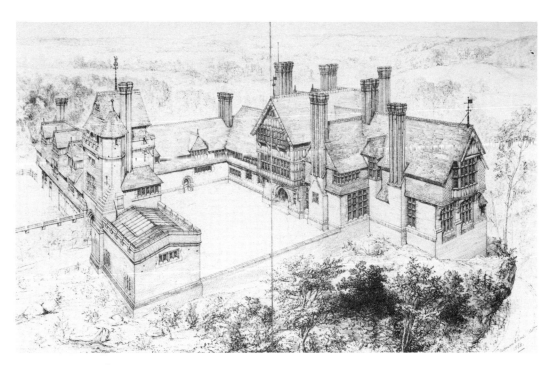

Perspective view of
Leyswood,
Withyham, Sussex.
R. Norman Shaw,
1868.

Stanhope, Webb organised the spaces more casually. The house features a small stair hall, similar to Butterfield's at Coalpit Heath, around which the other ground-storey rooms are loosely grouped, an arrangement that contributed to the informality of house design in both Europe and the United States. Then, at Arisaig in Inverness-shire (1863), a mansion of country-house size, Webb's organisation of a two-storeyed hall with gallery above and rooms opening off at both levels takes on a grand scale that was echoed in the English architect R. Norman Shaw's interior design for Leyswood (1868) at Withyham in Sussex. For Leyswood's exterior, however, Shaw drew on Early English architecture to clad his building with tile and to apply half-timbering and bargeboard gables over his brick structure to create the appearance of a medieval manor house. Perspective views of Leyswood, published in *Building News* of 1871, made an impression in both Britain and the United States.

THE COTTAGE ORNÉ IN THE NEW WORLD

In the seventeenth century, European settlers brought the principles of the yeoman's cottage to the New World, where it was

readily adopted. Abundant forests, rock and grasses provided the necessary timber, foundations and thatching, and the basic needs of the settlers were satisfied by the simplicity and flexibility of the rustic cottage mode. The colonists' one-room cottage of the seventeenth century developed into a symmetrical plan with a hall and parlour flanking the main entrance with kitchen and dining-room behind and bedrooms above, setting the example for the Bracketed Mode.

THE BRACKETED MODE

The Cottage Orné was codified, explained and propagated in the United States by Andrew Jackson Downing (1815–52), whose *Cottage Residences* of 1842 had a broad influence on establishing it as the 'Bracketed Mode' in the United States (so-called because the brackets supporting the projecting roof covering are visible). Called the 'Rural Socrates', father of the 'flee-the-city movement', Downing started out as a landscape gardener, but it was as editor of the widely read *Horticulturist* and author of numerous books on the subject that he made his greatest impact on nineteenth-century American taste in middle-class housing. As author, critic and taste-maker, he was a major figure in the Picturesque Movement in America in the 1840s and 1850s.

With the pressure of the Industrial Revolution squeezing out the greenery in the cities, Downing, along with such eloquent spokesmen as William Cullen Bryant, called for a great 'central park' in the European tradition. Their efforts led to New York City's Central Park and Prospect Park, which became models for urban parks throughout the United States.

Downing emphasised the importance of a properly landscaped site for the bracketed cottage. He insisted on the correct kinds of plants, vines, shubbery and the like for the cottage. The house should not only look picturesque from the outside, it should have picturesque views from the inside and from the veranda. The veranda was introduced to the United States probably from the West Indies in the eighteenth century, and Downing was adamant that every house should have one (even though he published

designs without verandas for those who could not afford them). With Downing, begins the concept of indoor–outdoor living that remains an integral part of American life today. Ideas and illustrations published in *The Craftsman* early in the twentieth century demonstrate how much a part of American life Downing's ideas of the picturesque had become.

In addition to a carefully landscaped site, Downing's designs continued a growing preference for the open interiors of the elegant houses of the Greek Revival. As shown in the ground plan, for example, the opening between the library and the parlour is wide and the two rooms are separated by sliding doors, which, when open, allow the two rooms to act as one. Downing's homes feature bay windows to allow abundant natural light to enter his ample rooms (ceilings over 3 metres high). In *Cottage Residences* (1842), the most influential pattern book for domestic dwellings of the period, Downing presented perspective views of cottages along with ground plans and interior views, and his text explained that which his illustrations left out, such as indoor bathrooms and labour-saving devices of all kinds. Not an architect himself, Downing relied on Calvert Vaux and A. J. Davis, whose collaboration with Ithiel Town produced many important buildings in New York, for his house designs. With Downing's attention to family needs and efficiency within the context of picturesque design, Davis' plans featured variety in room size and shape, window arrangement and exterior massing.

Respectful of history, Downing's houses were in such styles as Gothic, Elizabethan, Italian, and Swiss chalet. But whatever the style, the house and its site, Downing insisted, should always provide an uplifting experience equally for those inhabiting it and for those looking upon it.

English pattern books were a primary source of inspiration to Downing, and he acknowledged his debt to J. C. Loudon's *Encyclopedia of Cottage, Farm and Villa Architecture* (1833). Indeed, a comparison of Downing's illustration of a villa-style house with that of S. H. Brooks' villa of 1839, from his *Designs for Cottage and Villa Architecture*, reveals one of the sources of Downing's Bracketed Mode, as well as the board-and-batten construction he advocated.

'Design in the Swiss Style of Architecture'; illustration from *Designs for Cottage and Villa Architecture* by S. H. Brooks, 1839.

A new form of wood construction was becoming popular in the Middle West at the same time that Downing's Bracketed Mode was gaining popularity in the East. Augustine D. Taylor, Hartford builder newly arrived in Chicago, in 1833 built St Mary's Church in Chicago using light standardised beams and studs (the steam-driven saw had arrived in Chicago by 1832), th. newly introduced '2 × 4' and '2 × 6' (planks 2 inches thick by 4 or 6 inches wide), nailed together by another innovation – cheaply produced wire-cut nails, much more economical than forged nails. The new light lumber and cheaper nails eliminated reliance on traditional joinery, which was much more time-consuming. The light wood frame that resulted from this 'balloon-frame construction', as it was dubbed,

88

went up quickly, like blowing up a hot-air balloon, and appeared to its first witnesses just as flimsy.

THE STICK STYLE

The Olmstead house of 1849, in East Hartford, Connecticut, by English architect Gervase Wheeler, continues the Downing tradition, but the revealed skeleton of the house's wood frame and the open relief-like supports beneath the eaves emphasise the skeletal structure of the house. Moreover, Wheeler painted the house a light colour, highly unusual in the Downing tradition. Downing maintained that the colour of a cottage should blend with the landscape colours around it. Wheeler's exception in the Olmstead house is significant. The deep porch created by the unusually high-pitched roof casts deep shadows over the exterior of the house. Fearful that the skeleton of the house would not be seen if the house was the colour of the landscape, he chose a light hue so that the skeleton would be revealed.

The structural reality of the frame and the sensibility that made its visibility desirable contributed to what became known as the 'Stick Style'. Unlike Downing's modest cottages, however, Stick Style houses were usually large and often designed by prominent architects for wealthy patrons. With improved systems of central heating introduced around 1860, larger houses also became practical. Perhaps the earliest Stick Style house was the Griswold house in Newport, Rhode Island, by architect Richard Morris Hunt in 1862, and one of the boldest is the Sturtevant house of 1872, in Middletown, Rhode Island, by architect Dudley Newton. Both reveal the open stick work and diagonals that reflect the influence of Elizabethan half-timbering that was fashionable and a revived interest in early colonial frame structures.

As the Stick Style was born, Catharine Esther Beecher published her designs (1869) in *The American Woman's Home: or, Principles of Domestic Science* for houses that were 'healthful, economical, and tasteful'. The kitchen was designed so that there was a space and place for everything, a system that has become known as 'classified storage'. The plumbing, stairs, chimney and all service functions

Griswold House,
Newport, Rhode
Island. Richard
Morris Hunt, 1862.

were arranged in a compact central core, freeing the floor space around for rooms with access to fresh air and natural light. Beecher even designed a bathroom near the back door so that the gardener would not have to track through the house to get to it. Moreover, she designed such conveniences as wardrobe closets that became moveable walls for greater spatial flexibility. With her functional theories of house planning, Beecher has been credited with creating the modern American house that would be raised to the level of a fine art by Frank Lloyd Wright (born in 1867, just two years before Beecher's book was published) in the early twentieth century.

The ample interiors and grand scale of the Stick Style houses were popular especially in the popular summer resorts, such as Newport, Rhode Island. It was soon discovered that shingles were ideal cladding transformed to an attractive pearly hue by the sea air. The experimentation of sophisticated architects brought new and interesting designs and ornament that in the 1870s led the way to the Shingle Style.

THE SHINGLE STYLE

The Shingle Style was inspired in part by the so-called Queen Anne Style of Richard Norman Shaw: brick, tile roof, small-paned

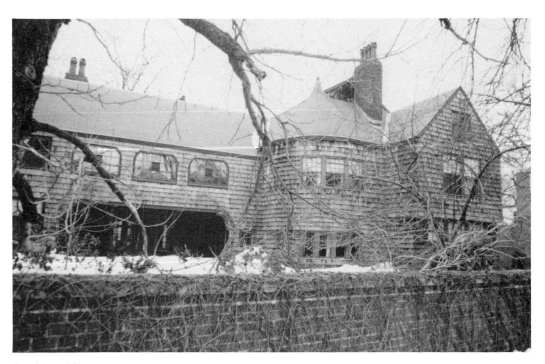

Stoughton House,
Cambridge,
Massachusetts.
H. H. Richardson,
1882–3.

bay windows, ribbon windows, high clustered chimneys, gables, and a free and open plan. However, vernacular architecture continued to influence the selection of materials and the interior organisation.

Shingle Style house interiors feature a great central stair hall, two or three storeys high, with large fireplace, inglenooks and comfortable furniture. Wide openings, 5–10 feet wide, open off the hall into the drawing-room, parlour and dining-room. A free flow of spaces into each other throughout the house is a distinguishing characteristic of the Shingle Style house, influenced in part by Japanese art and architecture seen at international exhibitions, prints and paintings that influenced the Impressionists, and such startling examples as James Whistler's Peacock Room, now in the Freer Gallery in Washington, DC.

Henry Hobson Richardson's Shingle Style houses were the first successfully to coordinate the free flow of interior spaces, Shaw's motifs and shingle cladding. In Richardson's Stoughton house of 1882–3 in Cambridge, Massachusetts, for example, the medieval turret that houses the stair hall, the small panes of glass and rows of ribbon-like windows beneath projecting bays, clustered chimneys and shingle pattern echo Shaw's ideas already well known from Leyswood.

VICTORIAN VARIATIONS

Popularisation of the Stick Style, the Shingle Style and the Queen Anne Style is due, in part, to English architect Charles Eastlake's designs in *Hints on Household Taste*, published in 1868. The book was reprinted in the United States beginning in 1872, and it had numerous editions, which exerted a strong and widespread influence on the architectural decoration of the late nineteenth century.

The most remarkable single example to illustrate the wide range of the so-called Eastlake Style is the William McKendrie Carson house in Eureka, California, designed by architects Samuel and Joseph Newsom, and constructed between 1883 and 1885. Carson, the owner of redwood forests in California, is believed to have used every available kind of wood in the construction of his house and to have kept over a hundred carpenters at work during a time when employment was scarce.

Equally remarkable is the 1300 block of Carroll Avenue in Angeleno Heights, Los Angeles, California – the finest collection of Queen Anne and Eastlake houses in Southern California. This concentration of Victorian architecture dates from the 1880s and remains intact because the residents, joined as the Carroll Avenue Restoration Foundation, have thoughtfully restored their houses, installed period lighting, and finance vigilant and ongoing maintenance programmes through regularly scheduled house tours. The houses, each with its own distinguishing features, make up a small architectural encyclopaedia of Queen Anne–Eastlake Victoriana: fish-scale shingles, lace-like trim, angular wood panels, wrought-iron work and high gables.

ANGLO-AMERICAN TRANSITIONS

As the Stick and Shingle Styles borrowed from English models, they in turn would influence late nineteenth-century domestic architecture in England with their open plans. Meanwhile, American architects began to adapt classical styles in innovative ways.

Symmetrical and classical plans characterise McKim, Mead and

Queen Anne Style
cottage, Bedford
Park. R. Norman
Shaw, 1876.

White's work at the turn of the century, for example. The William
G. Low house in Bristol, Rhode Island, of 1887 is covered by a
single massive pitched roof in a symmetrical plan, and the neo-
Georgian H. A. C. Taylor house of 1886 in Newport, Rhode
Island, is classical in plan and detail. The variety possible within the
classical or academic revival is illustrated in McKim, Mead and
White's Villard Houses in New York City of 1883–5, inspired by
the Cancelleria Palace in Rome.

SHAW, LUTYENS AND VOYSEY By the 1870s, renewed inter-
est in vernacular and classical forms began to replace the waning
interest in Gothic architecture in England. While Norman Shaw
continued to build manor-style country houses, he also laid out the
first garden suburb, Bedford Park (1876), complete with church,
tavern, shops, and Queen Anne Style cottages of red brick, with

93

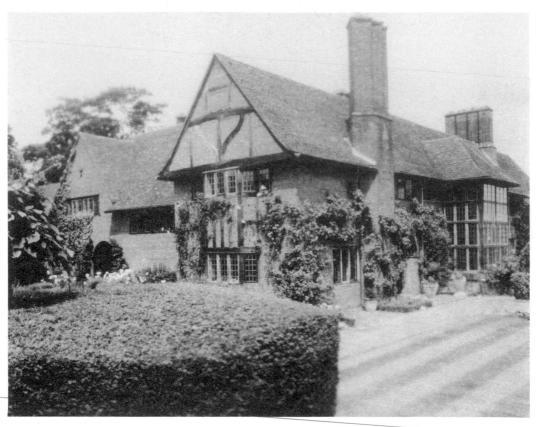

Deanery Gardens,
Sonning, Berkshire.
Sir Edwin Lutyens,
1901.

gabled roofs, small-paned windows, and tile roofs. He also
designed large London houses such as Old Swan House (1876) on
Chelsea Embankment in the Queen Anne Style with a formality
that predates the classical style of his late work, at the turn of the
century, in which he incorporated columns and classical motifs, as
in the Piccadilly Hotel (1905).

Sir Edwin Lutyens (1869–1944), a follower of Shaw, was one of
the leading architects to draw on the vernacular forms of his native
county, Surrey. His work is best exemplified in his Deanery
Gardens at Sonning in Berkshire of 1901 with its small-paned bay
windows, massive timbers, and two-storeyed hall. In the following
decades, Lutyens was to develop a neo-Georgian style in line with
the classical tradition that prevailed among fashionable architects
then. (Lutyens was also celebrated outside the purely domestic
sphere for the architecture of New Delhi in India and many public
buildings in Britain.)

Influenced by Morris and Mackmurdo, Charles Francis
Annesley Voysey (1857–1941) was a designer as well as an archi-

94

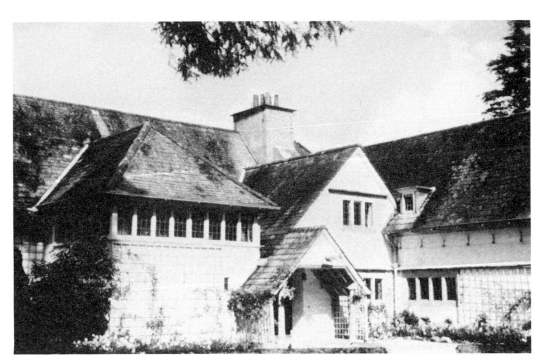

Broadleys, Lake
Windermere,
Cumbria. C. F. A.
Voysey, 1898.

tect, placing as much emphasis on furnishings and siting as on the
plan of the house. Voysey's houses are characteristically placed in
an intimate relationship with nature, and they blend vernacular
features of rough materials and steeply pitched roofs with rounded
bays and ample window walls providing views of country and rivers,
as in Broadleys on Lake Windermere, of 1898.

Voysey's innovations extended to a more open plan influenced by
the American Stick and Shingle Styles, yet one in which each space
is neatly contained. At the beginning of the twentieth century,
Voysey's work was internationally known, and his designs were
widely imitated. By 1910, Voysey had stopped building, and the
Prairie Houses of Frank Lloyd Wright brought the detached house
to maturity.

FRANK LLOYD WRIGHT AND THE PRAIRIE HOUSE

It was in the work of Frank Lloyd Wright that many of the notions
expressed by the varied styles of the nineteenth century came
together to produce highly innovative solutions to everyday living.
Even though Frank Lloyd Wright's contributions to architecture
were made in the twentieth century, he has been called America's

95

greatest nineteenth-century architect. This remark, intended to disparage the architect, contains a profound insight, because Wright was indeed a product of nineteenth-century sensibilities and developments and cannot be divorced from its traditions and influences. Indeed, his first work, the Hillside Home School, a Shingle Style structure, was built for his aunts near Spring Green, Wisconsin in 1887.

Born in Wisconsin, he spent his early years in New England, then the family moved back to Wisconsin, where Midwestern farm life contributed to his affection for the land and nature, which was to have a pervasive influence on his domestic architecture for the rest of his life. He saw nature and architecture both governed by the same principles of organic growth. While at the University of Wisconsin, he was attracted to the writings of John Ruskin, especially *The Seven Lamps of Architecture*. Wright himself would later formulate a list of nine principles essential to successful architecture. And the structural determination of Viollet-le-Duc, in which the form of a building expressed its structure, influenced Wright's thinking throughout his career.

Trained under Louis Sullivan in Chicago, Wright distinguished himself in domestic architecture as Sullivan dedicated himself to commercial building, most notably the skyscraper. Wright's most influential ideas in domestic architecture were formulated at the turn of the century in his Prairie Houses, a design for which was published in the *Ladies' Home Journal* in 1901. The Prairie House is a synthesis of nineteenth-century developments in the detached house and modern technology transformed by Wright's unique genius for organic design into a new house type. This new form was to have profound influence on the formulators of the early twentieth-century International Style as well as on the architects of today.

His published design in the *Journal* and his design for the Warren Hickox house, Kankakee, Illinois, 1900, typify the influential components of the Prairie House. A low-pitched gable roof, with wide projecting eaves, shades broad ribbons of windows that appear more like screens dissolving the wall allowing a new-found interpenetration of outdoors and indoors – a concept pioneered by A. J. Downing half a century before. Wright's houses, as

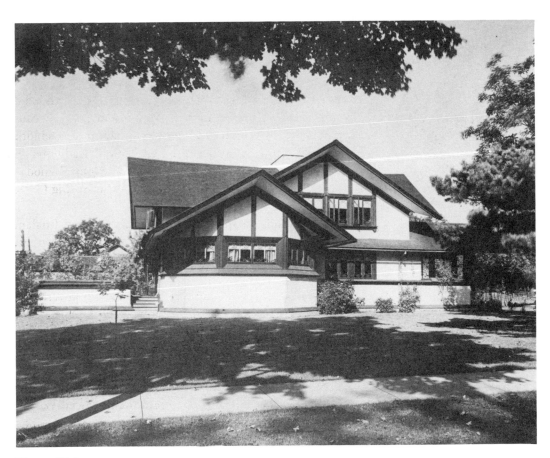

Warren Hickox
House, Kankakee,
Illinois. Frank Lloyd
Wright, 1900.

Downing's, are impeccably landscaped and practically designed.

Wright believed that man's first shelter began as a covering for the hearth. He therefore arranged his principal rooms around the fireplace, creating cross-axes that extend from it. This feature is evident at the roof where the low chimneys are located at the axial intersections. The large fireplace is reminiscent of the stair halls of the Shingle Style. Wright's interiors are ample and open. The absence of doors and wide openings allow one room to flow into another, a feature that reflects Wright's debt to Japanese architecture, examples of which he saw at the Japanese Pavilion at the Columbian Exposition in 1893.

In Wright's impeccable crafting of every detail, even in the service areas, he raised to a fine art the ideas embodied in the pioneering houses of Catharine Beecher. In this, Wright was also influenced by the Arts and Crafts Movement, which emphasises hand-crafted art in opposition to machine-made objects. While Wright used, rather than rejected, modern technology, he paid

97

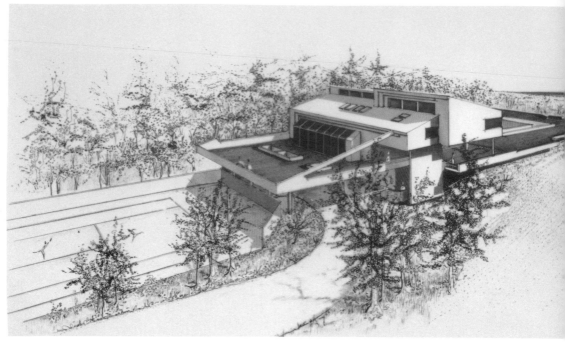

Maldonado house, Hamptons, New York. Agustin Maldonado, 1982.

great attention to materials, textures and interior furnishings. This he had in common with the practitioners of the so-called Craftsman Style, whose populist ideas were propagated through Gustav Stickley's *Craftsman* magazine and in the opulent bungalows of such architects as Charles and Henry Greene in California, whose matchless combinations of woods, metals and stained glass, exemplified in the Gamble house (1909) in Pasadena, California, produced a vernacular mode that surpassed Wright's elegance.

THE DETACHED HOUSE TODAY

It is noteworthy that ideas which had their origins in the yeoman's cottage of the Middle Ages and were raised to new levels of sophistication in the nineteenth and early twentieth centuries still prevail in the detached house today.

This is well illustrated in a house in the Hamptons in New York, 1982, designed by architect Agustin Maldonado. The interpenetration of indoor–outdoor living, for example, pioneered by Downing and perfected by Wright, is brought to remarkably new heights through a blend of sensitive design and modern technology. The house is sited on a broad expanse of ocean beach fronting a rolling

stretch of land between the Atlantic Ocean on the south and the Great South Bay on the north.

Elevated over $4\frac{1}{2}$ metres above ground, the house rests on a hundred pilings concealed from view. Walls of glass provide the principal living spaces below and the bedrooms above with views of the Ocean or the Bay, or both. A cantilevered balcony, appearing to float above the beach, extends from the bedrooms and provides enclosure and shade for the spaces below and dramatic views of Ocean, Bay and open sky above.

For long life, the wood frame is clad in modern materials that provide resilience for shifting and resistance to weathering. The new materials are blended with natural woods in soft textures of sandy and rose hues to pick up the ever-changing colours and light of the surrounding beach and landscape. Imported marble and tiles and a variety of natural woods enhance the interior spaces. The architect has conceived the house, landscape and seascape as one great intermeshed sculpture.

Conclusion

No comparable period in architectural history has seen such giants in design, technology and planning as the nineteenth century: from Paxton, Eiffel and the Roeblings to the masters of the skyscraper including William Le Baron Jenney, Cass Gilbert and George B. Post.

Reverberations of the nineteenth century continue to the present day. The visionary tradition of Ledoux and Boullée shaped the perceptions of architects and planners for generations and continues to have an impact on modern practitioners. The great classical temples of culture, commerce and industry in Europe and the United States are echoed in twentieth-century plans, designs and details, notably in such phenomena as the eclectic and short-lived Postmodernism of the 1970s and 1980s. Moreover, innovations in nineteenth-century domestic architecture that drew on historic models are echoed in some of the most successful designs and structures of the modern age in both Europe and the United States.

Until recently, the architecture of the nineteenth century had been seen as transitional from the great traditions of the Renaissance to the innovations of the twentieth century. But now specialists acknowledge that the range of notable achievements in design, technology and architecture produced from the mid-eighteenth century to the beginning of the twentieth has been outranked by no other century-and-a-half in the history of Western architecture.

Glossary

ABACUS the horizontal slab on the top of the capital in a classical column.

ARCHITRAVE the lowest component of an entablature.

ARCHIVOLT the continuous moulded surface of an arch.

BAY principal division of a structure, such as a wall, or its parts.

BRACKET support, usually in the form of a decorative scroll, for a projecting element such as a roof.

CAGE CONSTRUCTION built like a cage in which the weight of the building is carried by the framework, usually steel.

CAPITAL the crowning component of a column.

CELLA the central enclosure of a classical temple.

CLASSICAL REVIVAL conscious revival of classical architectural and decorative forms from ancient Greece and Rome.

COFFER sunken relief ornamentation of geometric shape in a vault.

CORBEL projecting block (usually stone) to support a beam or other horizontal member; a continuous row of corbels is called a corbel table.

CORNICE the top and projecting component of an entablature; also, the crowning moulding along the top of any structure.

CRENELLATION (= battlement) squared indentations (from 'crenel', a notch) at the top of a wall, for crossbows in medieval architecture.

CURTAIN WALL cladding affixed to the supporting frame of a skyscraper, a wall that hangs like a curtain from the skeletal construction of the building.

DIAPER WORK decoration consisting of a small repeated pattern that covers the entire surface.

DORMER window, with its own roof, in a sloping roof.

ECLECTICISM practice of combining various architectural and decorative elements into a coherent design or style.

ENTABLATURE the upper part of a wall or storey of a building usually supported by columns and composed of a frieze, architrave and cornice.

FACADE front or face of a building.

FENESTRATION arrangement of windows in a building.

FERROVITREOUS CONSTRUCTION method of construction combining iron (*ferro*) and glass (*vitreous*).

FRIEZE band of decoration; in classical architecture the band that extends parallel to and beneath the cornice.

GABLE the triangular component of a wall at the end of a pitched roof.

GALLERY second storey; in churches the corridors over the side aisles.

GLAZING fitting with windows or glass; the windows or glass themselves.

GOTHIC REVIVAL (= neo-Gothic) conscious revival of late medieval architectural decorative forms and techniques.

IMPOST the block between the abacus and the capital.

KEEP (= donjon) the main tower of a castle.

LANCET pointed arched opening.

LINTEL horizontal member over an opening, as in a window or door.

MANSARD roof whose surface is divided into two parts, the lower part being longer and steeper than the upper part (from the name of the French architect François Mansart).

NEOCLASSICISM the classical revival of the 18th and 19th centuries begun as a reaction against the Late Baroque and Rococo.

PATTERN BOOK book usually encyclopedic or technically illustrative in nature whose contents serve as patterns for builders, designers, architects and artists.

PEDIMENT a low pitched gable above a portico.

PENDULE a decorative fixture suspended and stationary from a fixed point.

PICTURESQUE style in which buildings and landscapes are characterised by artful irregularity, asymmetrical composition, and variety of textures, as in the Cottage Orné.

PILASTER shallow pier divided into base, shaft and capital, rectangular in profile and projecting slightly from a wall.

POLYCHROMY made of or decorated with different colours.

PORTE-COCHÈRE a gateway for the passage of vehicles.

PORTICO the roofed entrance to a temple, house or church.

PREFABRICATION fabrication of buildings or their standardised components at the factory for assemblage at the construction site.

RIBBON WINDOWS fenestration in which the windows extend horizontally in ribbon-like fashion.

RUSTICATION masonry composed of large blocks with edges hammered to emphasise the joints.

SPACE-FRAME (= space-grid) framework in which all elements equalise loads.

SPANDREL surface between two arches in an arcade; also the wall panel beneath a window-sill extending to the top of the window of the storey below.

TEMPLE FRONT facade composed of portico, pediment and columns, like the front of an ancient classical temple.

TERRACE separate houses constructed as a continuous unit.

TRACERY ornamental interlacing work in windows, screens and panels.

TREFOIL ornamental figure with three foils or lobes like a clover leaf.

VAULT arched covering usually in stone, brick, wood or plaster.

VERNACULAR STYLE style that uses forms native to a place, region or culture.

WEBBING mortar infill between the ribs in medieval vaulting.

Further reading

Arnason, H. H. *History of Modern Art: Painting, Sculpture, Architecture.* Abrams, 1968

Boase, T. S. R. *English Art 1800–1870.* Oxford University Press, 1959

Burchard, J., and A. Bush-Brown. *The Architecture of America: A Social and Cultural History.* Little, Brown, 1961

Clark, K. *The Gothic Revival, an Essay in the History of Taste.* Holt, 3rd edn, 1962

Colvin, Howard. *Royal Buildings.* Country Life Books, 1968

Condit, Carl. *American Building Art.* Oxford University Press, 1960

The Chicago School of Architecture. University of Chicago Press, 1964

The Rise of the Skyscraper. University of Chicago Press, 1952

Downing, Andrew Jackson. *Cottage Residences.* Wiley & Putnam, 1842

Evans, Tony, and Candida Lycett Green. *English Cottages.* Viking, 1982

Freeland, J. M. *Architecture in Australia.* Penguin, 1982

Gardiner, Stephen. *Inside Architecture.* Prentice-Hall, 1983

Giedion, S. *Space, Time, and Architecture: The Growth of a New Tradition.* Harvard University Press, 4th edn, 1962

Gifford, D., ed. *The Literature of Architecture: The Evolution of Architectural Theory and Practice in Nineteenth Century America.* Dutton, 1966

Gloag, John, FSA Introduction. *The Crystal Palace Exhibition* (illustrated catalogue). Reprinted by Dover, 1970

Hamilton, George Heard. *The Art and Architecture of Russia.* Penguin, 1954

Nineteenth and Twentieth Century Art. Library of Art History Series, H. W. Janson, General Editor. Prentice-Hall, 1970

Hamilton, Talbot. *Greek Revival Architecture in America.* Reprinted by Dover, 1964

Hitchcock, Henry-Russell. *Architecture: Nineteenth and Twentieth Centuries.* Penguin, 2nd edn, 1963

The Architecture of H. H. Richardson and his Times. Anchor, rev. edn, 1961

Early Victorian Architecture in Britain. 2 vols., Yale University Press, 1954

Hofmann, W. *The Earthly Paradise: Art in the Nineteenth Century.* G. Braziller, 1961

Honour, Hugh. *Neo-Classicism.* Penguin, 1968

Irwin, David. *English Neoclassical Art: Studies in Inspiration and Taste.* Faber, 1966

Kaufmann, Jr, Edgar, ed. *The Rise of an American Architecture.* Praeger, 1970

McCullough, David. *The Great Bridge.* Simon & Schuster, 1972

Marx, Leo. *The Machine in the Garden.* Oxford University Press, 1964

Meeks, Carroll L. V. *The Railroad Station.* Yale University Press, 1956

Morrison, H. *Louis Sullivan: Prophet of Modern Architecture.* Museum of Modern Art, New York, 1935

Norberg-Schulz, Christian. *Meaning in Western Architecture.* Praeger, 1975

Nuttgens, Patrick. *The Story of Architecture.* Prentice-Hall, 1984

Oakley, C. A. *The Second City.* Blackie, 1985

Peisch, M. L. *The Chicago School of Architecture: Early Followers of Sullivan and Wright.* Random House, 1965

Pevsner, Nikolaus. *An Outline of European Architecture.* Penguin, 7th edn, 1963

Pioneers of Modern Design, from William Morris to Walter Gropius. Penguin, rev. edn, 1964

Praz, Mario. *On Neoclassicism.* Northwestern University Press, 1969

Reynolds, Donald Martin. *The Architecture of*

New York City: Histories and Views of Important Structures, Sites, and Symbols. Macmillan, 1984

Richards, Jeffrey, and John M. MacKenzie. *The Railway Station: A Social History.* Oxford University Press, 1986

Robertson, E. Graeme and Joan. *Cast Iron Decoration: A World Survey.* Whitney Library of Design, 1977

Rowan, Alistair. *Garden Buildings.* Country Life Books, 1968

Schmutzler, Robert. *Art Nouveau.* Abrams, 1964

Scully, V. J. 'Romantic Rationalism and the Expression of Structure in Wood: Downing, Wheeler, Gardner and the "Stick Style", 1840–1876', *Art Bulletin,* 35 (1953), 121–42

The Shingle Style: Architectural Theory &

Design from Richardson to the Origins of Wright. Yale University Press, 1955

Spencer, Charles. *The Aesthetic Movement.* St Martin's Press, 1973

Summerson, J. *Architecture in Britain 1530–1830.* Penguin, 4th rev. edn, 1963

Victorian Architecture in England. Norton, 1970

Turnor, R. *Nineteenth-Century Arts in Britain.* Batsford, 1950

Vaux, Calvert. *Villas & Cottages.* Harper & Bros., 1864. Reprinted by Dover, 1970

Ward, Robin. *Some City Glasgow.* Richard Drew, 1982

Watkin, David. *The Picturesque in Architecture, Landscape and Garden Design.* Harper & Row, 1982

Wills, Elspeth. *Scottish Firsts.* Scottish Development Agency, 1985

Acknowledgements

The publishers are grateful to the following for permission to reproduce photographs:

Arcaid, pp. **93** (photo: Lucinda Lambton), **94** (photo: Lucinda Lambton; Architectural Association Slide Library, pp. **17** (photo: Valerie Bennett), **18** (photo: F. R. Yerbury), **21** (photo: James Bogle), **48** *above left*, **63**, **64** (photo: Andrew Higgott), **81** (photo: Taylor Galyean), **84** (photo: Colin Penin), **90** (photo: Andrew Holmes), **91** (photo: Jackie Lynfield), **95** (photo: Gillian Wilson); The Bettmann Archive, pp. **45** (2), **54**, **68**; Bibliothèque Nationale, Paris, p. **9**; The British Architectural Library/RIBA, London, pp. **27**, **75**, **85**, **88**; Camera Press, pp. **15**, **65**; Syndics of Cambridge University Library, pp. **31**, **40**; Edifice, p. **48** *above right*; Richard Gardner, pp. **19**, **35**, **43**; Giraudon, Paris, pp. **7**, **11**; Robert Harding Picture Library, London, p. **53**; Impact Photo, London, pp. **18** (photo: © Steve Sandon), **29**, (photo: Keith Bernstein); A. F. Kersting, pp. **4**, **10**, **23**, **37** *below*, **44**, **58**, **77**; The Frank Lloyd Wright Archives © The Frank Lloyd Wright Foundation, p. **97**; MAS, Barcelona, p. **78**; © Agustin Maldonado, p. **98**; © Donald Martin Reynolds, p. **56**; Peter Rogers Photographic, Stafford, p. **34**; Russia & Republics Photo Library, pp. **13** (2); Edwin Smith, pp. **8**, **32**, **46**, **48**, **82**, **83**; Münchner Stadtmuseum, Munich, p. **74** *above*; Victoria & Albert Museum, London, pp. **60**, **62**; Virginia Division of Tourism, USA, p. **5**. **Cover:** Arcaid (photo: Mark Fiennes).

Picture research: Maureen Cowdroy.

Index